IMAGES
of America

MILLS ALONG
THE CARSON RIVER

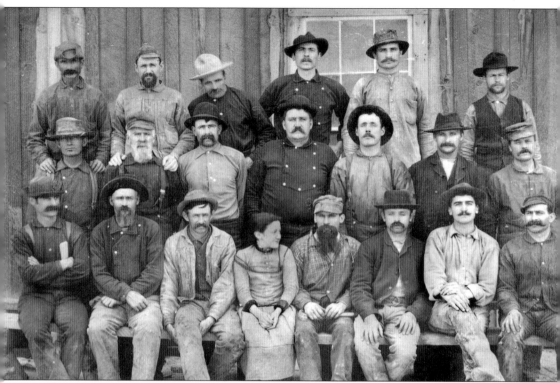

Shown above is the Eureka Mill crew in the 1880s. The Eureka Mill was one of the largest quartz mills on the Carson River and at this time had 21 employees. The woman was the cook, as the employees usually lived at the millsite and food was provided. A crew usually consisted of a superintendent, millwrights, amalgamators, laborers, carpenters, feeders, furnace men, and mill men. The employees were of all different nationalities and had to work closely together, which could be hindered by those that did not speak very good English. It was common for a mill crew to be of the same nationality. (Courtesy of the Nevada Historical Society.)

ON THE COVER: Nevada Reduction Works Mill, which was first built as the Rocky Point Mill in 1860, was one of the longest-running mills along the Carson River. Although it was completely destroyed by fire twice in its life and flooded, it was always rebuilt. It was finally torn down in 1920, and the stamps were shipped to Silver City to be used in the Donovan Mill. (Courtesy of the author.)

IMAGES
of America

MILLS ALONG
THE CARSON RIVER

Daniel "Dan" D. Webster

ARCADIA
PUBLISHING

Published by Arcadia Publishing
Charleston, South Carolina

Printed in the United States of America

Library of Congress Control Number: 2014954973

For all general information, please contact Arcadia Publishing:
Telephone 843-853-2070
Fax 843-853-0044
E-mail sales@arcadiapublishing.com
For customer service and orders:
Toll-Free 1-888-313-2665

Visit us on the Internet at www.arcadiapublishing.com

This book is dedicated to my children, Elaine and Dave, my grandchildren, Raechel, Joma, and Alexandria, and any others that may come along. It is also dedicated to those who are trying to preserve, document, and teach our history before it is lost forever.

CONTENTS

Acknowledgments 6

Introduction 7

1. Setting the Stage 9

2. Mills along the Virginia & Truckee Route 17

3. Mills down the Canyon 81

4. Mills in Dayton and Beyond 89

5. Dredging along the River 111

6. Corruption at the Mills 121

Acknowledgments

I would like to acknowledge photographers like Carleton Watkins, Lawrence & Houseworth, and others who lugged their heavy cameras and tripods up hills and over the rough dirt roads, and those journalists and magazine editors who thought what was taking place on the Comstock was worth documenting. I am grateful to those who kept these photographs and documents and preserved them for our enjoyment today. If it were not for these historians, this book would not have been possible. Unless otherwise noted, the photographs in this book appear courtesy of the author.

I would like to thank Joyce Cox and her staff at the Nevada Library and Archives, as they were a great help, as well as the Nevada Historical Society for its extensive library and photograph collection. Thank you to the Nevada State Museum for the use of some of its collections; as well as Fred Holabird for use of his reference library; Stephen Drew for his research and photograph collection; and Jan Bixby, who accompanied me on the many exploratory and photographic trips down the Carson River. I would lastly like to thank my children, Elaine and Dave, for supporting me in this lengthy project.

INTRODUCTION

The gold and silver quartz mills along the Carson River played a very important part in the development of the Comstock Lode at Virginia City, Gold Hill, and Silver City, Nevada. There is not as much written about the mills as there is about the mines, but without them the bullion recovered from the Comstock ore would not have its place in history on such a grand economic scale.

When gold was discovered in the Carson River in 1850s, prospecting started up Gold Canyon toward Virginia City. The gold ore was similar to that of California, which the prospectors knew how to work. However, along with this gold was a blueish rock that was thought to be waste. It clogged their sluice boxes. The Grosh brothers discovered the blue rock was high-grade silver ore and began filing claims and taking samples that were assayed by themselves and companies in San Francisco. Both brothers perished before their story could be told, and their samples and claims were stolen.

When the word reached California that gold had been discovered, miners quickly began relocating to Nevada. Hugh Logan and J.P. Holmes were two of them. Convinced there was enough ore to make a mine, Logan went to San Francisco and ordered a mill. They, along with a Mr. Hastings and Jos Woodworth, built the first mills along the Carson River. The Logan and Holmes mill, although crude, showed that the values of the Comstock ore could be recovered using this type of mill. This led to a rush to survey the Carson River for land ownership and water rights. Water was used to provide the main power for the mills as well as the recovery process.

Some authors note that when a mine was found, instead of putting the money in the mine to develop it, the owners built a mill, and by the time the mill was completed, they did not have enough money to develop the mine. Most of the first mills along the Carson River were owned by men with mines in Gold Hill. The distance between these mines and the river mills was about seven to nine miles, and the ore was freighted for $7 per ton by horse-drawn wagons.

The gold and silver ore of the Comstock had to be crushed to liberate the values. California ore when crushed was mostly free gold, which means the crushed solution was passed over plates with mercury on them, which picked up the gold, or run through sluice boxes. The Comstock ore, especially the silver ore, was more complex, which meant special processes had to be used. The ore was crushed to talcum-powder fineness before the values could be recovered. The *arrastra* (mill) and patio process used by the Mexicans used stones to grind the ore with mercury to recover the gold and silver. This process was used with the Comstock ore and was very slow. An invention called a pan was developed to speed the recovery process. These pans, and there were quite a few makes, used steel bottoms and steel shoes to crush the ore and mix it with the mercury, which absorbed the gold and silver. From these pans, the solution went through agitators, separators, sluice boxes, and settlers depending on the recovery process used at a specific mill.

Many of the mill owners who were building their mills needed money. They borrowed money from the Bank of California, of which William Sharon was the Virginia City agent. Everything went well for the mill owners until the ore quality dropped, and many could not pay their debts.

This crisis came to a head in 1866, and the bank suddenly owned many of the mills on the Carson River.

William Sharon and the bank found the costs of transportation from the mines to the mills to be excessive. In 1867, the cost of horse-drawn transportation of ore to the mills on the Carson River was too expensive to make the processing of the lower-grade ores profitable. Sharon decided it was time to build a railroad from Virginia City to the Carson River mills. The rail line was completed to Gold Hill in 1869 and to Virginia City in 1870.

Ore trains started delivering ore to the Carson River mills. Special sidings, ore cars, and rock chutes were built along the river to accommodate the unique situations of each mill. The railroad also delivered ore to other mills along the river where their tracts did not go, and that ore was taken by horse and wagon the rest of the way. Supplies for the mills, mines, and population of Virginia City, Silver City, and Gold Hill were now freighted by the railroad. Later, the rail line was extended to Reno, where it linked up with the recently completed transcontinental Union Pacific Railroad, which reduced the shipping rate for supplies, most of which were coming from San Francisco.

Many of the first mills along the river did not last long. They were small mills, some of the processes they used did not work with the Comstock ores, and the mills faded away. When the invention of dissolving gold and silver using cyanide was implemented successfully, most of the mills were converted to this procedure, as it was more efficient than the pan and amalgamation process. As the ore ran out and became too low a grade to be milled profitably, the mills started to process tailings. Tailings are ore that had been run through the mill and recovery process at least once. Because of the inefficient processes used in the beginning, it was found that these tailings contained large amounts of gold and silver that could be reworked with cyanide.

At the end of the 1890s, the Comstock ore had been played out, and the tailings had been reprocessed to the point that it was no longer profitable to work them. The mills along the river that were still in operation started to decline. There was much cleanup around the old millsites, which did pay off, as a lot of the solution and processed ore had been spilled and absorbed into the ground. The mills were gone by 1920.

Early in the milling process it was known that the processed ore that was let out of the mill into the Carson River, known as tailings, had significant values. Dredging the river to recover these values began around 1886. These dredging operations did not seem to be successful due to the type of material in the river. The river contained large rocks as well as fine sand that the dredging equipment could not work together.

As with any super money-making ventures, there can be greed and corruption. The stock manipulation of the Comstock mines by the mine owners has been highly publicized. The corruption and skimming of profits in the mills were less publicized. Unfortunately, because of this, the true wealth of the Comstock will never be known.

This book will take the reader on a journey down the Carson River from first mill to the west to the last mill to the east.

One

SETTING THE STAGE

With the successful results from the Logan and Holmes and the Hastings and Woodworth mills, along with the need for water to run the equipment and process the ore, the race was on by the men who owned the claims—mostly in Gold Hill at the time—to secure land and water rights for their mills. The milling of the ore by an arrastra was too slow, and knowledge of gold and silver ore by reduction using stamp batteries and amalgamating pans led to many very large mills along the Carson River. Large wooden water wheels were shipped from San Francisco and Sacramento along with the machinery necessary for the reduction of the ore. By 1862, according to Elliot Lord, there were 23 water-powered mills built and in operation or being built along the Carson River from west of the town of Empire to a few miles past Chinatown (Dayton), Nevada.

Even though the arrastra process was very slow, it is documented that there were quite a few mills on the river using them. Water, the principal source of power for the mills along the river, was critical to their operation. There were, however, years of low water due to lack of rain and snowfall, and the mills had to curtail their operation and sometimes even shut down. In very cold winters, the water in the river would freeze, and the same results occurred. Farmers were irrigating their fields with water from the Carson River upstream of the mills, and this also reduced the amount of water flowing to the mills. Particularly dry years led to conflicts between the farmers and the mill men. The mill men would send a man or two up the river and sometimes destroy diversions made by the farmers so the mills would have enough water. This led to hard feelings and eventually many lawsuits by the owners of the mills, which H.M. Yerington started in 1864. More information on these lawsuits can be found in Grace Dangburg's book *Conflict on the Carson*, published in 1975.

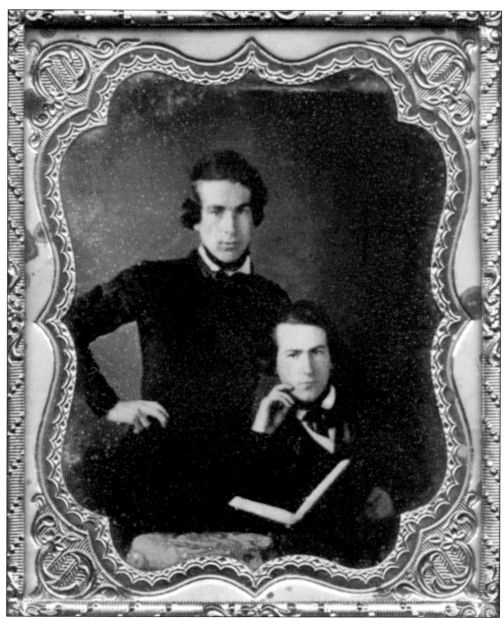

In 1857, E. Allen Grosh (left) and Hosea B. Grosh, originally from Philadelphia, Pennsylvania, were prospecting on the Comstock. They had a background in chemistry, assaying, and metallurgy and carried good and silver assaying equipment. According to letters to their father, they found valuable silver and gold ore. Unfortunately, Hosea stuck a pick in his foot and contracted gangrene, of which he died in September 1857. Allen went with their partner, Richard Bucky, to take some samples to San Francisco and then on to Philadelphia to raise money to open a mine. They got caught in a terrible snowstorm and could not build a fire. Bucky left to get help, but Allen succumbed to the cold. Their bag of samples was gone when Bucky got back to the cabin. The brothers' mining claims were staked too early for official record keeping, so their discoveries were over claimed by others, who received the initial credit for discovering the Comstock Lode. (Courtesy of the Nevada Historical Society.)

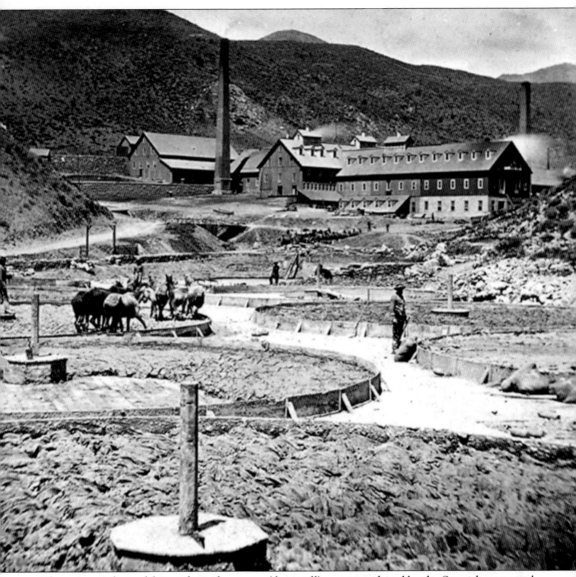

The arrastra, derived from *tahona de arrastre* (drag mill), was introduced by the Spanish to central and northwest Mexico early in the 1500s. It was used for the reduction of ore for more than 300 years, and with the discovery of gold in California, miners who were familiar with arrastras introduced them to the California miners. When gold and silver were discovered on the Comstock, arrastras were first used to crush the ore. The arrastra could be from eight to 20 feet in diameter, built with a flat rock base and an edge to contain the crushed ore. A heavy rock was drawn over the ore in a circle, usually by animals, making six to eight revolutions per minute to crush the ore and mix it with mercury, salt, and bluestone (copper sulfate). The mercury picked up the gold and silver, and when the employee running the mill was assured that the ore was totally crushed, he stopped the process. The arrastras pictured were at the Gould and Curry Mine in Virginia City.

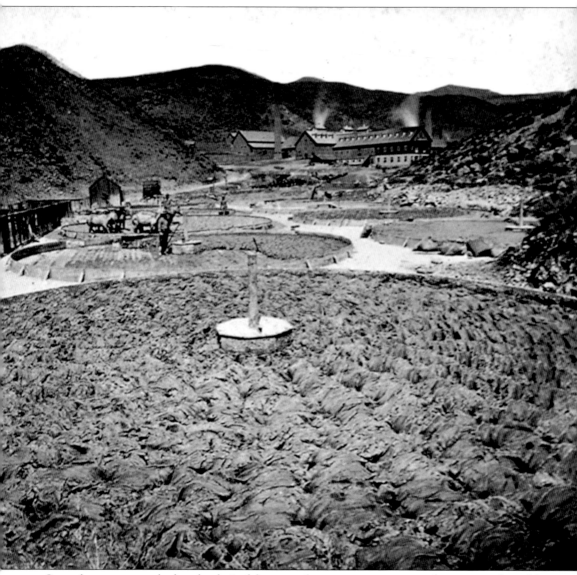

Once the ore was crushed to the desired fineness, the patio process was used to recover the gold and silver. Animals were used to continue to mix the mercury, salt, and bluestone (copper sulfate) with the crushed ore. When the ore was thoroughly mixed with the chemicals, the mixture was allowed to set in the sun on a patio, thus the name "patio process." The patio process was invented by Bartolomé de Medina in Pachuca, Mexico, in 1554. The sun heated the mixture and allowed the rich, dense amalgam to separate from the waste. The material was then transferred to tanks where it was washed and the amalgam recovered. The amalgam was then heated in a retort to separate the gold and silver from the mercury, allowing the mercury to be used again. The mixture in the foreground arrastra has been mixed by the animals, and the feet patterns are evident. The middle arrastra is being cleaned out, and the ore mixture is ready for the separation process.

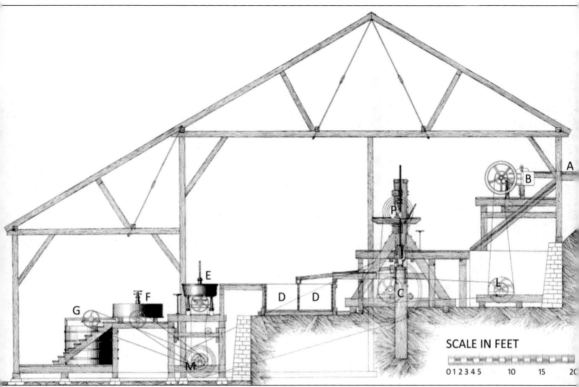

Above is the layout of the stamp mill that took the place of the arrastra. The ore entered the mill at (A) and was dumped through a grizzly to obtain the correct size. The ore that did not go through the grizzly was broken up by a worker until it was the proper size. The ore was then introduced to a crusher (B), which was two moving plates that crushed it to a smaller size, usually three-fourths of an inch, ready for the stamp battery (C). The stamps of the battery weighed from 750 to 1,000 pounds and were lifted by a cam (P) rotated on a shaft. This action is like placing the ore on a steel plate and pounding it with a hammer until the desired fineness was obtained. The ore was kept inside the stamp battery by a screen until it was the correct fineness. This fine mixture, almost like talcum powder, was then fed to tanks (D), pans (E), separators (F), and agitators (G). Water was used to facilitate the process.

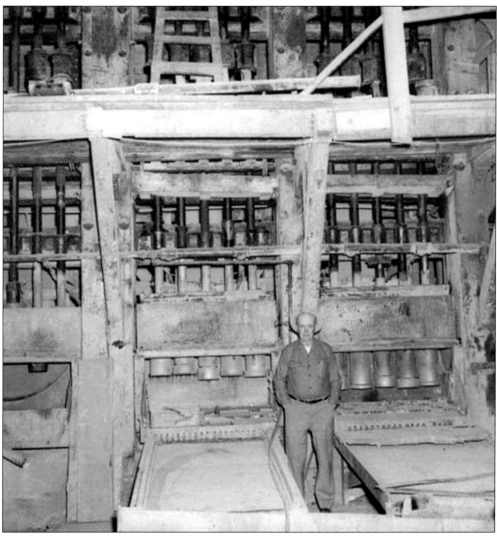

Pictured here is a close up of a mill's stamp batteries. Each battery was usually five stamps, which were attached to long rods and lifted up seven inches by cams, then dropped, and hit the bottom shoe, which was the same size as the stamp head. The ore, already crushed to a fairly small size, was automatically fed to the battery. Both the stamp head and shoe were removable, as they would wear. Evidence of this can be seen in the photograph when looking at the bottom of the stamps. This battery of stamps, which is currently in the Donavan Mill in Silver City, Nevada, came from the Rock Point Mill on the Carson River when it shut down in 1920. The screen that kept the crushed ore in the stamp battery until the desired fineness was achieved is missing in the photograph, but it would be at the front of the battery held by slots in the base. In this mill, the already-crushed mixture would flow over amalgam plates and then into the tanks, pans, separators, and agitators.

To separate the gold and silver from the amalgam (mercury), it is heated in a retort. When the temperature is high enough, the mercury vaporizes and is directed through a tube to cool and reform as liquid mercury, which is captured in the receptacle. What is left in the retort is then taken to the smelter for further processing. The captured mercury can be used again.

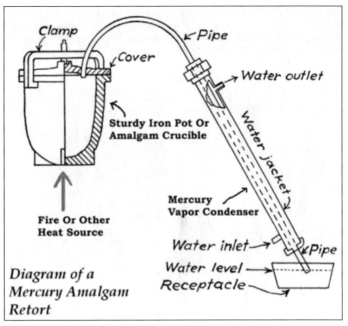

Diagram of a Mercury Amalgam Retort

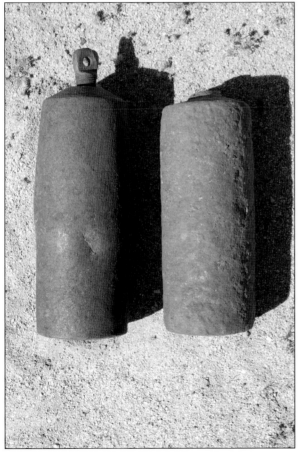

Mercury was transported in cast-iron or steel flasks that contained 76 pounds of mercury. The flasks were 12 inches to the top lip by 4.5 inches in diameter. Most of the mercury came from the Almadin Mine in California. These flasks were found at a Carson River mill. The plug at the top of the flask was removed to pour the mercury.

15

Ore wagons like this one were used to haul the Comstock ore to the mills along the Carson River. This wagon is being weighed at a scale in Virginia City. The transportation costs were charged by the ton and ran between $7 and $9. The Virginia & Truckee Railroad replaced the need for many of these wagons after it was built in 1869.

Shown here is a piece of the granite base of an arrastra near Randsburg, California, that was about eight feet in diameter. This base stone is four inches in thickness and appears to have been set in a concrete-type mixture. The grooves in the stone were made from dragging the large crushing stone around the arrastra. The arrastra was called a "poor man's mill" because it was the best and cheapest all around gold- and silver-crushing device at the time.

Two

MILLS ALONG THE VIRGINIA & TRUCKEE ROUTE

The mills in this chapter are the mills that were serviced by the Virginia & Truckee Railroad. Before 1869, when the railroad was built, the ore was shipped to the mills by wagon over toll roads. Sometimes each mill had its own toll road from its mine to the mill, as using other toll roads was very expensive. In severe winter conditions, many of these roads were impassable. After 1869, the ore was shipped by train, which not only reduced costs but was also more reliable, especially in the winter. The first two mills at the west end of the Carson River were built at a location where the water was not high enough to obtain the power necessary to run the mills. A dam built close to these mills was impractical, as it would have to be about one half-mile in length and flood all the lowlands behind it. Instead, a large dam with a long ditch called the Mexican Dam and Ditch was built up the canyon to supply the water.

The other mills in this chapter also had dams with ditches, the longest being 1.1 miles in length and belonging to the Eureka Mill. Some of the mills required spur tracks with trestles to deliver the ore to the mill. Other mills had rock chutes to transport the ore to the canyon close to the mill. The Eureka Mill had an ore chute and later a tram along with a railroad of its own to transfer the ore to the mill. All the mills in this chapter were run with water power supplied by the Carson River until the mill men realized that in low-water years and in winter the mills could not run because of lack of water. Steam boilers were added to run some of the mills but could not run the number of stamps water power could. There was one surveyed millsite on the Carson River that was never built. It was the Trench Mill, which instead was built in Silver City, and the land surveyed for the millsite on the Carson River was later incorporated into the Santiago Mill.

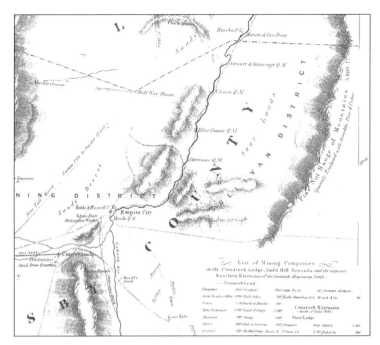

This 1862 Bancroft map shows the mills that will be covered in this chapter, starting with the Silver State Reduction Works Q.M. (Mexican Mill) and ending with the Eureka Q.M. The Q.M. stands for quartz mill. Each mill had a section of land associated with it. In 1862, there were seven mills; the Morgan and Brunswick has yet to be built, and the Mead and Blue Canyon/Copper Canyon were in decline.

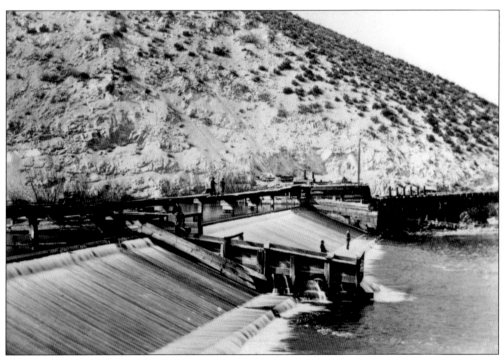

Pictured here is the Mexican Dam, built in 1860 to provide water to the Mexican and Mead Mills, which were also being built at that time. The dam, which is still in place today, is approximately 300 feet in length and 10 feet high. Originally an earthen dam, it was upgraded after it was destroyed in a flood to a concrete dam with a fish ladder in the center.

Pictured here in 1997, the Mexican Dam is still in the same configuration. It is private property and partially fenced to try to keep swimmers from swimming in the pond. There are very dangerous currents in the pond, and a few years ago, two brothers drowned while swimming. The water that flows into the Mexican Ditch comes off to the right of the dam and is used for irrigating alfalfa fields today.

NUMBER 23 INCORPORATED MAY 25, 1909, UNDER LAWS OF NEVADA SHARES 20

CAPITALIZATION, $20,000.00
2,000 SHARES, PAR VALUE, $10 EACH

PRINCIPAL OFFICE, RENO, NEVADA

RESIDENT AGENT

March 10th 1916

This Certifies, that *C. A. Ambrose*

is the owner of *Twenty* Shares of the Capital Stock of

MEXICAN DAM & DITCH COMPANY

Transferable on the books of the Company by endorsement hereon and surrender of this Certificate.

John W. Wiggin
SECRETARY

C. A. Ambrose
PRESIDENT

THE WHITE COMPANY, RENO, NEV.

When the Mexican Mill ceased operation and the dam washed out in the early 1900s, Abe Ambrose purchased the water rights from the Union Mill & Mining Company and rebuilt the dam, turning the land into farming land. The Mexican Dam & Ditch Company was organized with Ambrose as president. The company still controls the dam, ditch, and water diverted for irrigation of the nearby alfalfa fields.

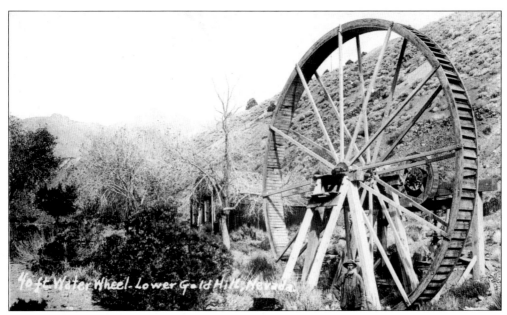

There are no photographs of the wooden water wheel that was used at the Mexican Mill or other Carson River mills. The wheel in this image illustrating their impressive size powered a mill at lower Gold Hill. The water wheel at the Mexican Mill was probably somewhat larger than this one, as it was the largest wheel on the West Coast at the time.

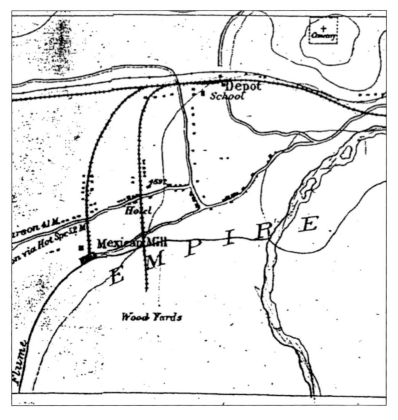

This 1877 Wheeler map details the layout of the Mexican Mill. The water came in from the flume, and the ore from the Comstock mines was fed to the mill by a spur track shown coming south off the main line of the Virginia & Truckee Railroad. There is another spur track to the J.A. Hoover wood yard (Wood Yards). The depot is the Virginia & Truckee Railroad's.

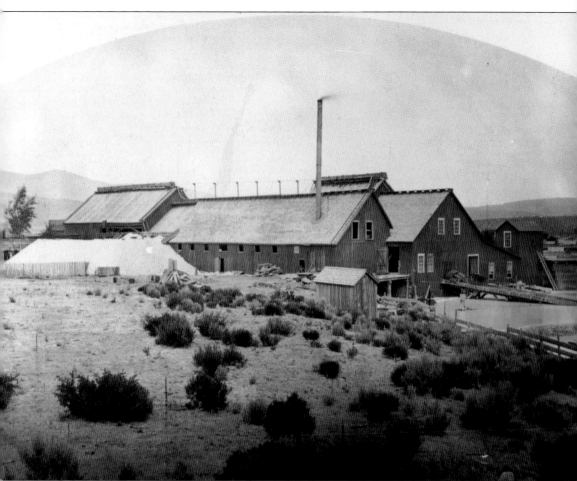

The Silver State Reduction Works (Mexican Mill) was originally built in 1860 with 12 stamps and J.M. Davis as superintendent. It burned and was rebuilt and enlarged in 1862 with 44 stamps processing ore from the Mexican Mine in Virginia City, Nevada. The recovery process first used was the barrel process. The ore was crushed wet and flowed through Brevoort grinders and then through 12 Mitchell amalgamators. The pulp then flowed into agitators and into vats where it was allowed to settle. The mixture was then spread out and allowed to dry, much like in the patio process. The mixture was then roasted with salt to make a chloride. After roasting, the mixture was run through barrels with added mercury and then through more agitators to insure all the silver had been recovered. Once that was done, the mercury was separated from the mixture and retorted to recover the gold and silver. The mill also used a dry process, but it was not as efficient. (Courtesy of the Nevada State Museum.)

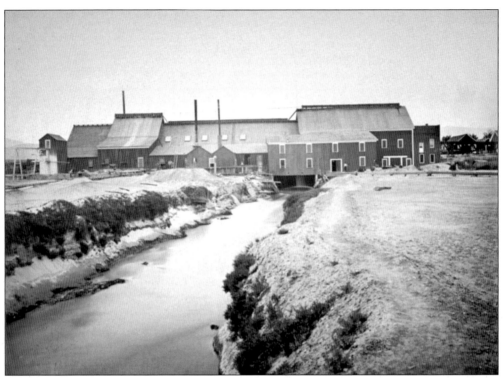

The mill comprised a crushing and amalgamating building 186 feet by 90 feet, a furnace shed 187 feet by 40 feet containing four furnaces with stacks 12 feet square at the base and 80 feet tall, and a fireproof brick assay office 20 feet by 40 feet. The superintendent in 1862 was E.B. Dorsey. The mill was also known as the Silver State Reduction Works and Spanish Mill.

Memorandum of Bullion

— OF THE —

PACIFIC MILL AND MINING COMPANY.

Mexican Mill, Consolidated Virginia Assay Office,

Deposited _3896_ Ounces. _Duplicate_ Virginia, Nev. _April 25_ 1878.

| BAR NO. | WEIGHT OF BAR. | | FINENESS. (1000ths.) | | VALUE OF BAR. | | | | | | VALUE OF SAMPLES. |
	OUNCES.	DEC.	GOLD.	SILVER.	GOLD. DOLLARS.	CTS.	SILVER. DOLLARS.	CTS.	TOTAL. DOLLARS.	CTS.	DOLLS. CTS.
7394	1919	90	33	959	1309	75	2380	48	3690	23	382
2395	1882	30	"	"	1285	46	2336	34	3621	80	382
	3804	20			2595	21	4716	82	7312	03	382

Henry G. Elder
assayer

Recorded here are bullion bars created by the Mexican Mill from processed ore belonging to the Pacific Mill and Mining Company. The bullion was assayed at the Consolidated Virginia Assay Office and the results recorded on this sheet. These bars would then be deposited at the mint in Carson City or a bank with credit to the mining company.

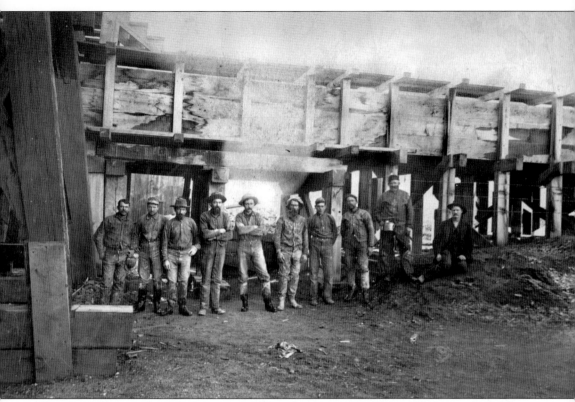

Above is a photograph of the Mexican Mill employees in 1888. Pictured here are, from left to right, Jake Laws, Owen Jones, William Sayers, John Christensen, P. Thompson, Mr. Smith, Lew Wagner, Mr. DeGray (DeCay?), Hank May, and Hi Brachue (Braskue or Braskul?). This photograph illustrates just how substantially the mills were built at the time. In 1861, when the mill first started up, there were nine employees. This fluctuated over the years, and in 1904, there were only four employees just maintaining and guarding the mill. During the life of the mill, the owners were Harrington, Atchison, and Kinkead (1861), Alsop and Company (1866), Mexican Mill Company (1866), William Sharon (1869), Union Mill & Mining Company (1870), Alvinza Hayward (1871), Alvinza Hayward and John P. Jones (1872), Union Mill & Mining Company and John P. Jones (1874), William Sharon and John P. Jones (1878), and Nevada Mill Company (1879–1903). (Courtesy of the Nevada Historical Society.)

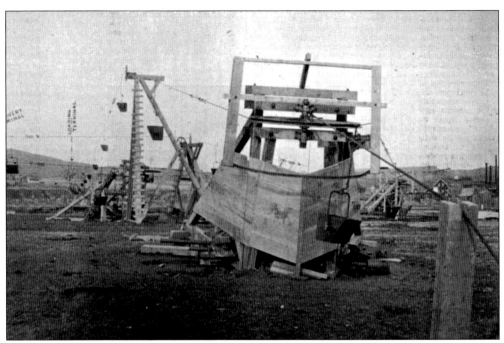

In 1894, Orrin B. Peck of Chicago leased part of the Mexican Mill ground and used its water to process the Mexican and Morgan Mill tailings. He and his brother installed a wire-rope tram to bring the tailings from the tailings pond across the river to their processing plant. This photograph from the *Engineering and Mining Journal*, dated 1896, shows the turn end and the wheel.

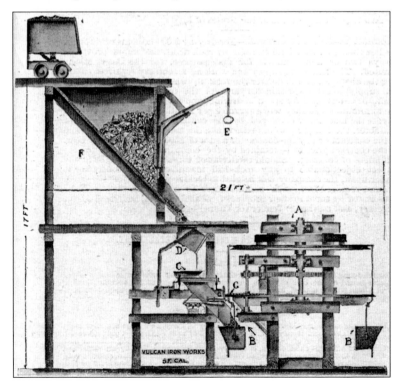

At the loading terminal, the tailings were dumped into bin F and then into holding bin D. They were then automatically released into the tram bucket B and carried to the mill. The large wheel and cable-holding mechanism can be seen at A. The tram could carry 200 tons per day.

The mill end of the wire-rope tram shows the automatic dumping system and the chute that carries the tailings to the mill. Due to the level ground, the tram only required an eight-horsepower motor. The cost of running the tram for loading, transferring, and dumping the tailings is stated to be the labor of one man. The approximate cost of the tram and its construction was $9,000.

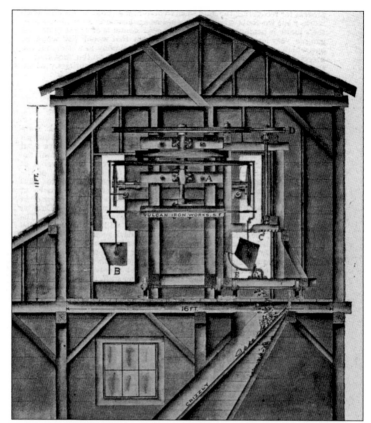

Shown here are the old mill and house that Nevada governor Jewett William Adams used for his gypsum plant. He used the power at the Mexican Mill along with the building to start his business. Gypsum was found to be a better building material, and there was a source of the raw material in Mound House, Nevada. He later moved the mill to Mound House. (Courtesy of the Roberts Collection.)

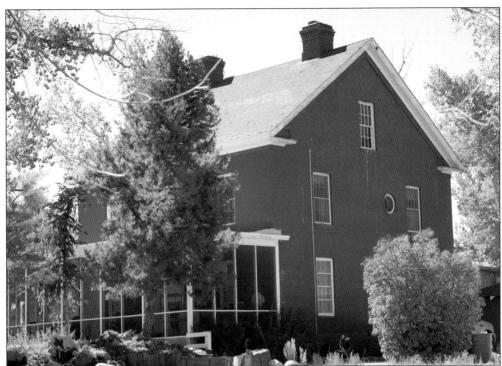

Above is the superintendent's house in 2014. The two-story residence was built as only a million-dollar firm would build it and is a private residence. Superintendents of the Mexican Mill that would have lived in the house were Edward B. Dorsey (1863), W.S. McDonald (1866–1870), and Dean B. Lyman (1870–1875). Evan Williams also lived in the house for many years before Abe Ambrose took it over in the 1900s.

This vista of Empire Ranch Golf Course where the Mexican Mill used to be was captured from the hill above the town of Empire, which can be seen toward the bottom right. A 1911 story tells of boys uncovering stolen amalgam at the Mexican Mill. The story started out as a large amount of amalgam, but in the end it was only a small amount maybe worth $10. (Courtesy of the *Carson Daily Appeal*.)

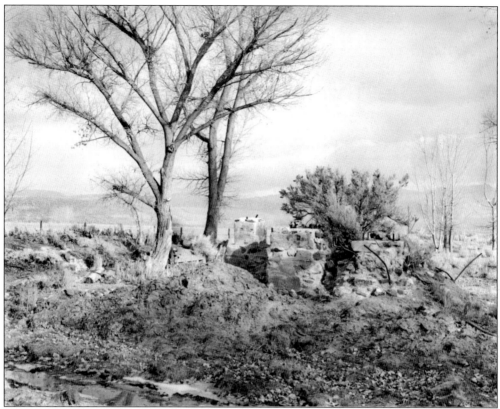

Above are the ruins of the mighty Mexican Mill around the 1960s. The only thing left is the cement foundations that supported the stamp batteries. There are only three of these in the photograph. These were left even though most of the cement and wood was crushed or burned to recover any material of value they may have absorbed. The golf course has preserved these ruins. (Courtesy of the Nevada Historical Society.)

Pictured here are remnants of the stone wheel of an arrastra found at the Mexican Mill. While Ambrose was cleaning up the Mexican Mill, he uncovered the remnants of an arrastra that was reportedly used by Mexicans before the influx of white settlers. The ore they were crushing was mostly free gold and nothing like the Comstock ore. It is uncertain where the ore came from. (Courtesy of the Nevada Historical Society.)

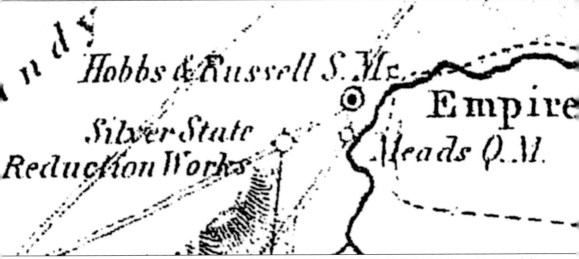

The Mead Mill was next to the Mexican Mill and was built in 1861 by William H. Mead for $25,000. The main building was 46 by 56 feet and contained 16 stamps and 10 stone pans using water from the Mexican Ditch. In 1863, Mead sold two-thirds interest in the mill to Joseph Baldwin Jr., and the mill was renamed the Baldwin Quartz Mill. Assessment records indicate the mill was never totally finished. In 1864, Mead sold half of his water rights and all of his interest in the land to James Morgan, who built the Morgan Mill farther down the river using the water from the Mexican Ditch, which had supplied the Mead Mill. The 1864 assessment records list the Ophir Silver Mining Company as owning the property formerly used in connection with the old Mead Mill. This image is from an 1877 Wheeler map.

This 1877 Wheeler map shows the location of the Morgan Mill and the tailings pond northwest of the mill. It also shows the Virginia & Truckee spur track for delivering the Comstock ore. The mill was built in 1864 at a cost of $150,000 and contained 40 stamps, 30 Hepburn pans, 15 settlers, 2 agitators, and 2 grinders. It was located approximately four miles east of Carson City.

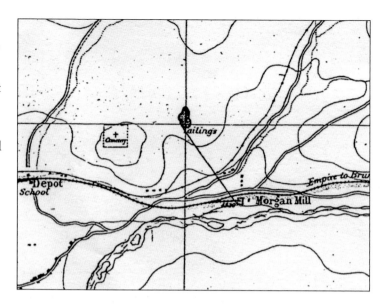

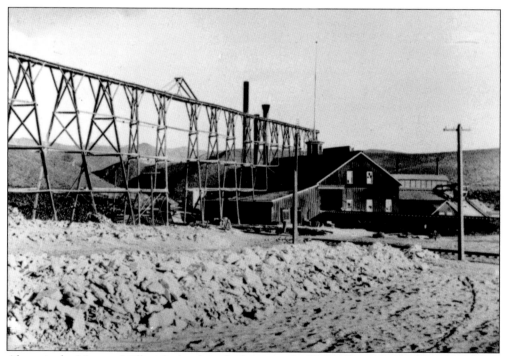

Above is the Morgan Mill with the sluice/tailings trestle. The mill was originally powered by a fine-turbine water wheel that developed 100 horsepower. In 1865, when the Yellow Jacket Company bought the mill, a 175-horsepower steam engine was installed, which allowed the mill to operate when the Carson River was nearly frozen or low in water. The engine, made by the Vulcan Iron Works of San Francisco, had an 18-foot flywheel.

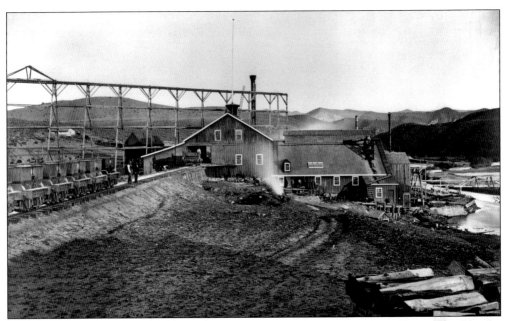

Shown here is the Morgan Mill with the ore cars at the left. In 1866, the mill was owned by the Yellow Jacket Mining Company and was named the Yellow Jacket Mill, crushing ore from that mine in Gold Hill. John B. Winters was superintendent. In 1867, H.R. Logan was superintendent. Alvinza Hayward and John P. Jones purchased the mill in 1871 and renamed it the Morgan Mill. (Courtesy of the Nevada State Museum.)

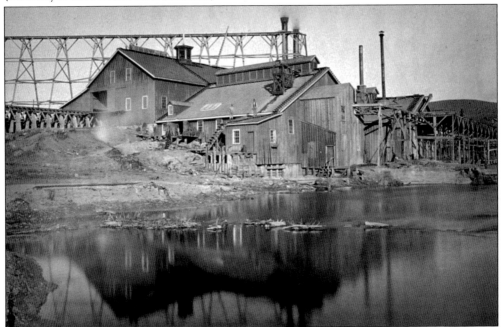

Above is the Morgan Mill at another angle. Alvinza later sold his portion in the land and half of the mill to the Union Mill & Mining Company. In 1878, the mill was sold to the Pacific Mill and Mining Company, and it was sold again in 1887 to the Comstock Mill and Mining Company, which owned the mill until it was torn down.

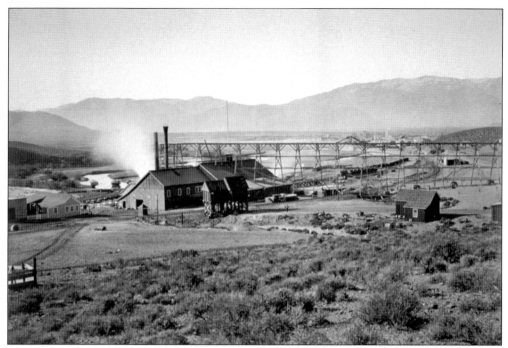

The mill is pictured here with the Carson River and houses to the left. In 1880, the mill employed 33 men: one foreman, two amalgamators, two blacksmiths, one blanket sweeper, one carpenter, two engineers, nine laborers, one retorter, 10 tank men, one teamster, and three others. There were five Americans, two Canadians, five Danes, four Englishmen, three Germans, eight Irish, one Norwegian, two Scots, two Swedes, and one Swiss.

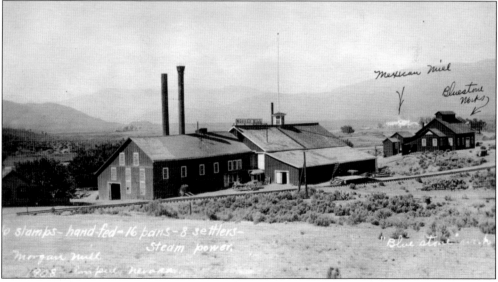

Above is a photograph of the mill, which is close to being torn down. The trestle has been removed and the wood shipped to Virginia City to be used for firewood, as there was a shortage of tinder. The Bluestone Works made bluestone, which was used in the process of reducing the Comstock ores. While in production, the mill processed ore from the following mines: Crown Point, Consolidated Virginia, and Union Consolidated.

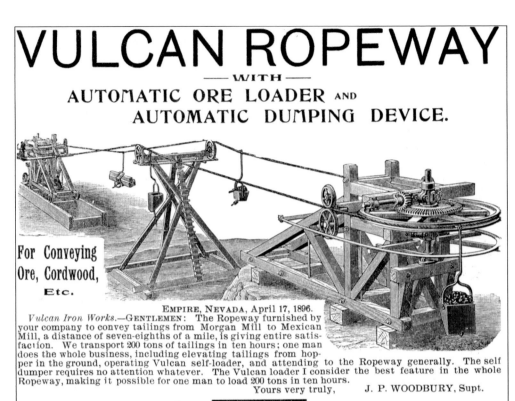

In 1894, Orin B. Peck of Chicago was given the right to work the tailings at the Morgan Mill by John P. Jones and the Union Mill & Mining Company. This lease cost $45,000. A wire-rope tramway made by the Vulcan Iron Works and similar to the one in the advertisement was used. Note the reference to the Mexican and Morgan Mills.

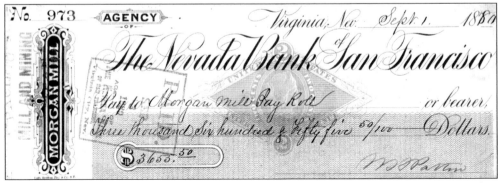

Around 1902, the mill was to be overhauled by J.P. Woodbury for a cyanide operation. The author does not believe this ever happened, because in 1903, the assessment cost for the mill was lowered by the board of equalization to $1,000. In 1910, a *Carson City Daily Appeal* article indicated the cyanide game was about at its finish with the final cleanup at the Morgan Mill.

In the 1940s, rock walls were all that remained of a building that was part of the Morgan Mill. It can be seen how well-built these mills were. It took quite a bit of time to build these mills; although the main structures were wooden, some of the houses, mill walls, and special buildings were made of brick or quarried stone. (Courtesy of the Nevada Historical Society.)

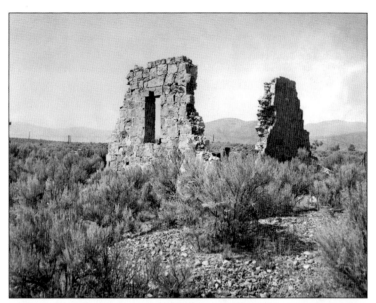

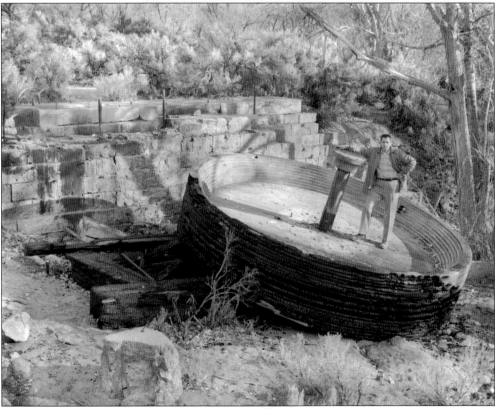

Pictured here is the wooden bull wheel, or drive wheel, that turned the cams, which lifted the stamps in the stamp battery. This and the quarried-stone foundations for the stamp batteries are all that was left of the Morgan Mill around 1950. The stairs from the floor to the stamp batteries can be seen in the middle left of the photograph. The bull wheel was burned around 1950 by careless campers. (Courtesy of the Nevada Historical Society.)

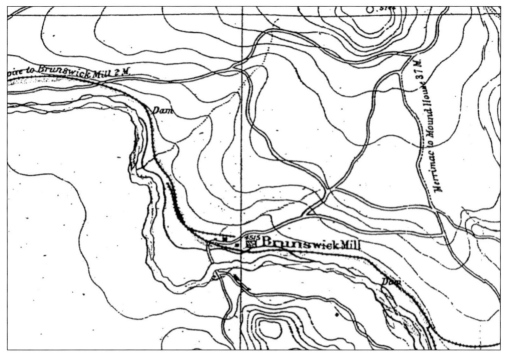

Pictured here is an 1877 Wheeler map showing the layout of the Brunswick Mill. The mill was approximately 1.5 miles east of the town of Empire. The land for the mill was originally surveyed by F. Tagliabue in 1861. The mill was not built until 1864. The map shows the Virginia & Truckee spur track that delivered the ore on to the mill.

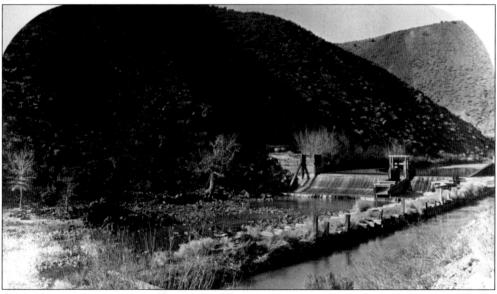

Pictured here is Brunswick Dam, with the water ditch in the foreground that fed the water to the mill. Wood was floated down the Carson River for transport to Virginia City, so screens were placed in front of the dams to keep the wood from clogging them and the water ditches of the mills. Today, if the water in the river is low, the wooden base of the dam is visible. (Courtesy of the Yerington Family Collection.)

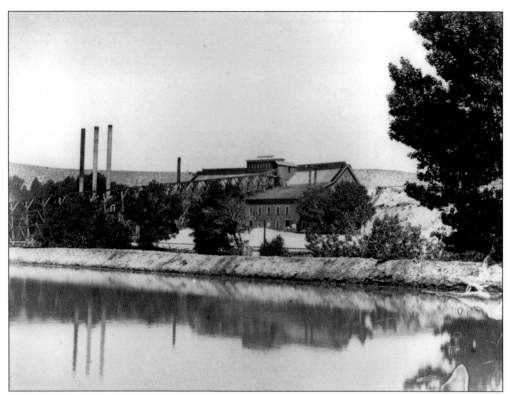

This photograph of the Brunswick Mill was taken from across the Carson River. The mill was water powered and cost $50,000. In 1863, the dam and ditch were completed to the mill. The mill at the time ran eight to 10 stamps, six pans, and four separators. Known as Reilly's Mill, the operation was crushing ore from the Chollar-Potose Mine and owned and superintended by Isaac Reilly.

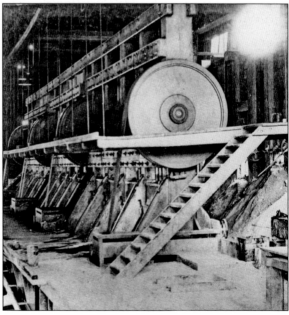

Shown here is the interior view of the Brunswick Mill, with the stamp batteries and the large bull wheel (drive wheel). The mill had been enlarged to 56 stamps by 1870 and again enlarged to 76 stamps in 1889. In 1903, twenty stamps had been refurbished and were in use in the mill-cleanup process. The mill was run by water and steam power.

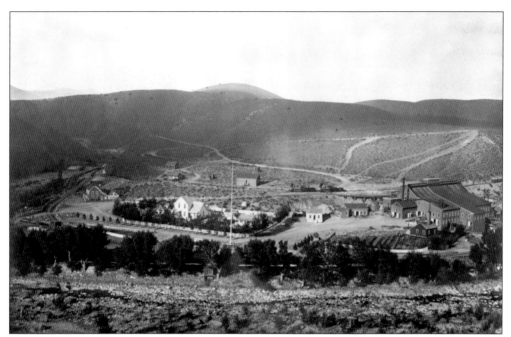

In the photograph above are the Brunswick Mill and buildings in 1876. The owners of the mill were many, along with those listed above; in 1871, the mill was purchased by the Crown Point mine, then by H. Hayward. John P. Jones purchased part of the mill in 1872. In 1875, the mill was purchased by the Pacific Mill and Mining Company, controlled by John William Mackay, James Graham Fair, James Flood, and William S. O'Brien. (Courtesy of the California State Library.)

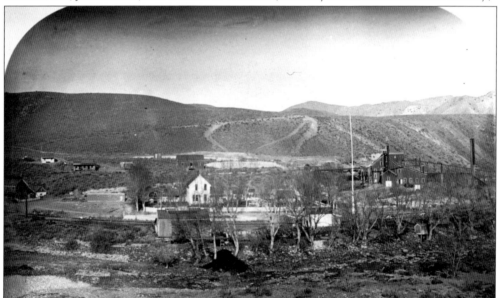

Shown above is another view of the Brunswick Mill layout in 1889. A comparison between this photograph and the previous one shows how the mill changed over time. The mill was a large complex and was designated as a stop on the Virginia & Truckee Railroad, as were some of the other mills. The Brunswick had an open passenger and freight platform, allowing passengers to picnic at the mill. (Courtesy of the Yerington Family Collection.)

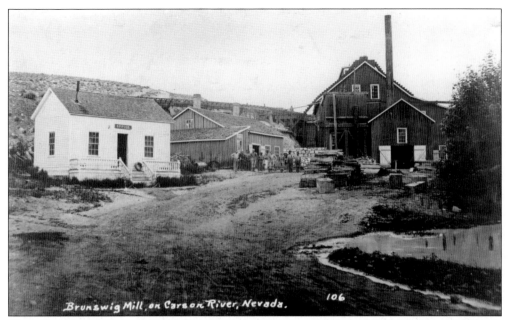

The mill superintendents were Isaac Reilly (1865), Col. Milton R. Estner (1870–1875), Evan Williams (1881–1891), H.R. Logan, and J.P. Woodbury (1893–1905), who also helped in the cleanup operation when the mill was scrapped. The mill went idle around 1896, but it was started up again in 1910 to process ore as well as material gathered up around the dismantled portion of the mill.

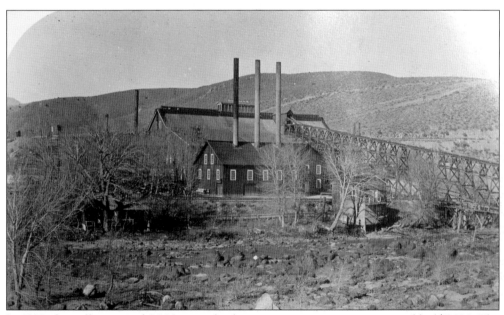

In 1889, the mill processed 1,300 tons of tailings in one year, giving a gross yield of $5,200. The cost of mining was $1,525, the cost of transportation was $320, and the cost of reduction was $2,600, a total cost of $4,445. Whoever was processing the tailings made $755. (Courtesy of the Yerington Family Collection.)

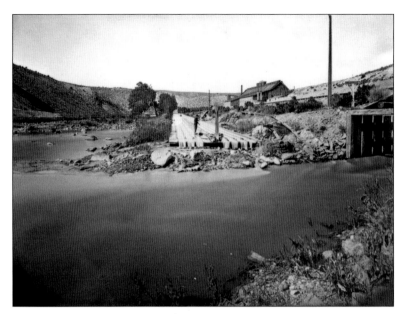

This man is standing on the sluice that emptied into the Carson River. The sluice was the last process the mills used to capture the values from the ore. They were usually troughs with blankets at the bottom that would catch the heavy particles of gold, silver, and amalgam. These sluices were developed around 1874.

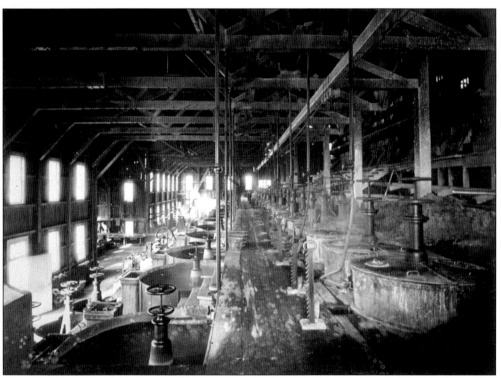

Pictured here is the interior of the Brunswick Mill showing the pan room. The stamp batteries can be seen at the top right and then the pans and settlers. This was the usual setup for each mill along the Carson River. The Brunswick Mill used a variety of pans, including Knox pans and Varney pans. In 1871, the mill had 26 pans and 13 settlers for recovering the values in the Comstock ores.

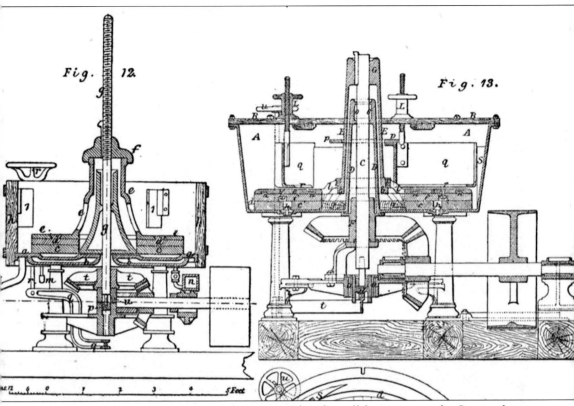

Fig. 12. Fig. 13.

Shown here is a cutaway of two pans that were used in the mill for processing the Comstock ore. The pan was much like an arrastra, as the shoes revolved around the pan in a circle and crushed the ore between them. Mercury was added, and the action pulverized the ore fine enough so the mercury would absorb the gold and silver. The Wheeler pan in figure 12 was one of the oldest pans used in the mills, as it was introduced in 1862. The pans were refined over the years to increase the recovery of the values from the ore and make them easier to work on. The Varney pan, figure 13, was one of the improvements used in the Brunswick Mill. The sides were cast in one piece or sections. They were iron or wrought iron instead of wood. The wear on these pans was tremendous, and many tons of pan parts, especially the shoes, were shipped regularly by the Virginia & Truckee Railroad from the foundries to the mills.

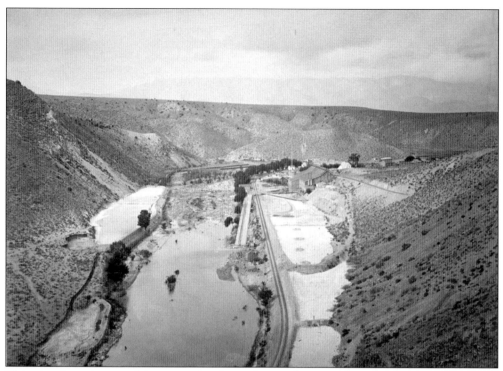

This view from the top of the mountain shows three tailings ponds in the center and the other tailings pond across the river. The mill is in the background. The sluice that was used to catch the last remaining values of the processed ore before the solution was discharged into the river is also visible to the left of the Virginia & Truckee Railroad's main line. The railroad's spur track to the mill is visible on the right side of the photograph.

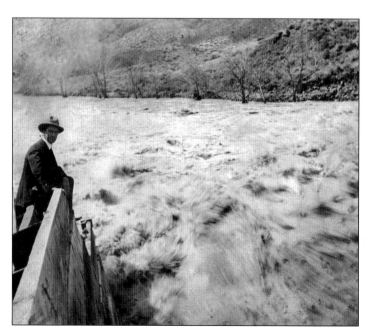

Shown here is Frank Kean standing by the Brunswick Dam in the 1897 flood. It appears that the dam was washed out. Unfortunately, when these floods happened, they caused heavy damage to all the dams along the river and sometimes to the mills themselves. It could take some time to fix these damages, and the mills would be shut down, which had an effect on the railroad as well as the employment in the mines. (Courtesy of the Nevada Historical Society.)

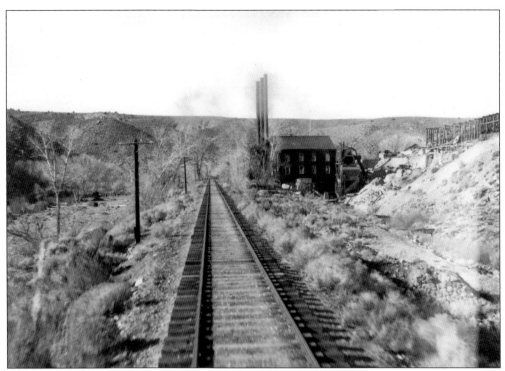

This photograph from the coach of the Virginia & Truckee Railroad in 1916 shows what is left of the once-mighty New Brunswick Mill. The mill's name was changed in 1866 to the New Brunswick Mill when it was enlarged. Most of the wooden trestles have been removed, along with some of the building. The rock crusher can be seen to the right of the mill. (Courtesy of Stephen E. Drew.)

At right is a photograph of the remnants of the Brunswick Mill. These are the foundations that supported the stamp batteries. The rock wall in the background is the back of the mill. In 1910, the Brunswick Mill was the only mill that was mostly intact out of all the Carson River mills along the Virginia & Truckee Railroad route.

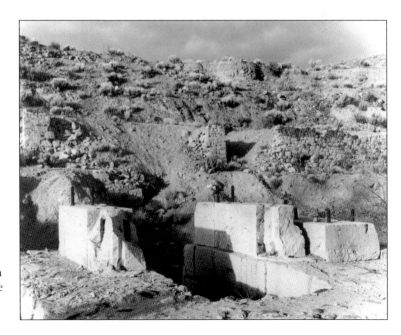

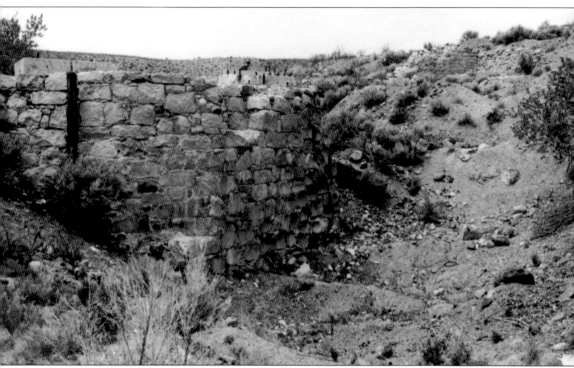

This remaining rock wall of the Brunswick Mill was possibly built by Chinese, as they did a lot of rock work for the mills and especially for the Virginia & Truckee Railroad. In 1873, Mrs. Dittonfieder kept a lodging house on Virginia City's South C Street, and on May 3, George Berry, who had been working at the Brunswick Mill, was taken to her house in a helpless condition, having fallen from the roof of the mill and sustained serious injuries. The Virginia City No. Two Fire Engine Company defrayed Berry's expenses, as he was entirely without means of his own. A Mrs. Naleigh acted for some time in the capacity of a nurse to Berry, and she fell in love with him, divorcing her husband to wed Berry. (Courtesy of the Nevada Historical Society.)

In 1883, a man named Retford who was employed at the Brunswick Mill was thrown from a derrick and seriously injured. A guy of the derrick had been stretched across the railroad tracks, and when the locomotive came along, it broke the guy. Retford was taken to Carson for treatment. The property was sold in 1883 to William Sharon and Robert F. Morrow, a prominent San Francisco capitalist, for $100,000.

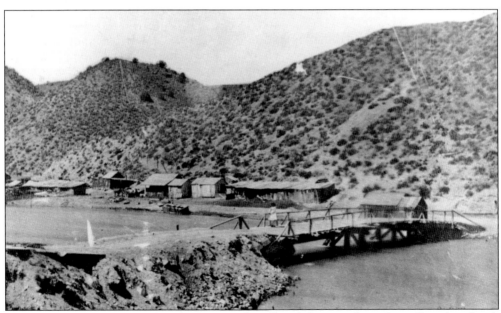

Shown here is the bridge below the Brunswick Mill with houses where the mill workers lived. There were so many people living at the Brunswick, Merrimac, Vivian, Santiago, and Eureka Mills that a voting precinct was set up at the Brunswick. Politicians came to the mill to give political speeches, and voting took place there also. The mill and property were sold to the Western Smelters Corporation in 1908. (Courtesy of the Nevada Historical Society.)

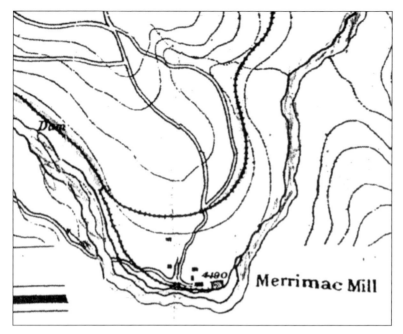

This is an 1877 Wheeler map with the location of the Merrimac Mill. The placement of the Merrimac Dam is shown at the left, and the Virginia & Truckee Railroad main line and spur going to the mill are visible. The ore cars that the railroad used to transport the ore to the mill had to be side-dump cars to accommodate the configuration of the mill.

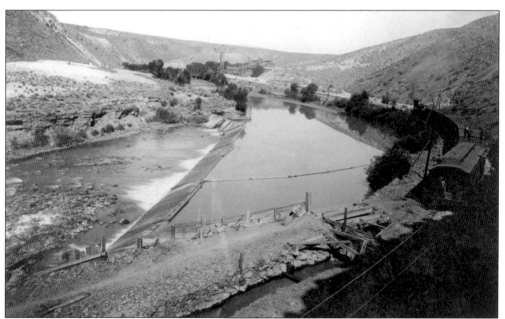

The water to run the mill was trapped by the Merrimac Dam and channeled through a 2,100-foot-long ditch, 14 feet wide and four feet deep, to the mill. In 1863, the dam was noted as one of the most substantial on the river. The Brunswick Mill can be seen in the background as well as the mixed freight and passenger train of the Virginia & Truckee Railroad. (Courtesy of the Nevada Historical Society.)

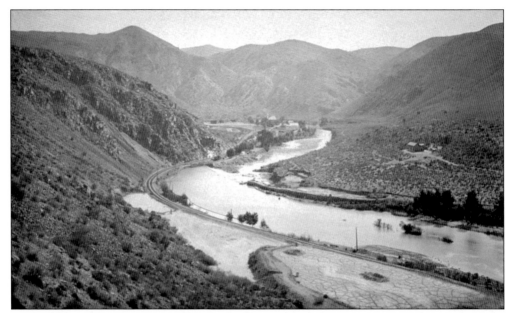

Pictured here is the Merrimac Mill in the background with the Virginia & Truckee tracks in the foreground. The pond of water next to the tracks is the pond made by the Merrimac Dam. The mill was built in 1861, washed out by a flood, and rebuilt further away from the river. The cost was $50,000. The water wheel was an 80-horsepower central-discharge wheel.

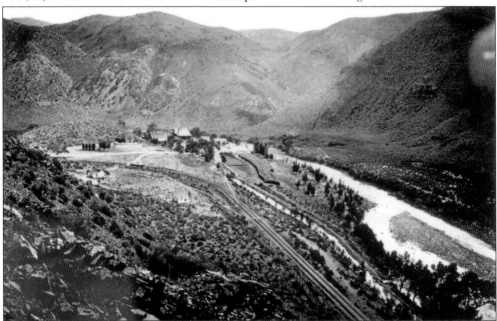

In the above photograph, the Merrimac Mill can be seen in the background with the Virginia & Truckee Railroad main line and the spur track going to the mill. The mill was built by Messrs. Bryant, Ellsworth, and Company. In 1863, A.M. and S.R. Ellsworth owned the mill, and S.R. Ellsworth was the superintendent. The Ellsworths sold the mill in 1865 to Henry M. Yerington and William D. Torryson, comprising the Merrimac Mill Company. (Courtesy of the Nevada Historical Society.)

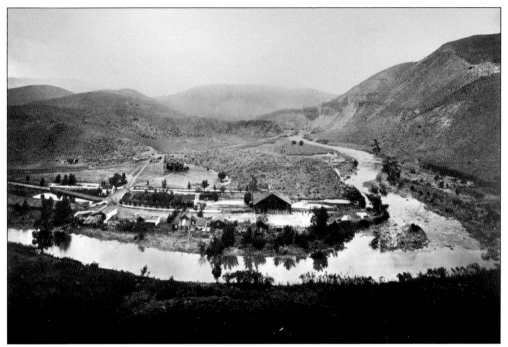

The Merrimac was on the bend in the river. In 1862, the main mill building was 56 feet by 100 feet and housed 16 stamps, which weighed 750 pounds each, 4 Knox pans, a Varney pan, 6 settlers, and 10 agitators, crushing 30 tons of ore per day using the Hatch process. The machinery was made by H.J. Booth & Company of Marysville, California. (Courtesy of the Nevada Historical Society.)

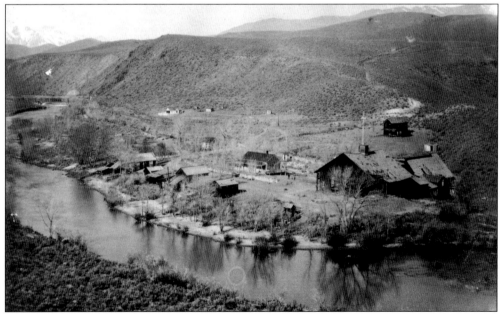

In 1866, the owners of the Merrimac were H.F. Rice and H.M. Yerington. The mill contained 20 stamps, 4 Knox pans, 15 Wheeler pans, 1 Varney pan, 6 large settlers, and 10 agitators, and it crushed 30 tons of ore per day. It also had one prospecting battery and pan. The ore came from a mine that was nine miles from the mill. (Courtesy of the Nevada Historical Society.)

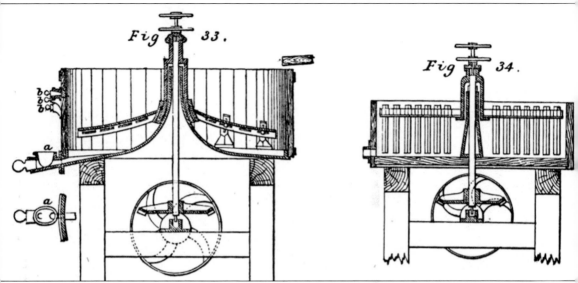

Figure 33 is a settler, which sometimes was only a wooden tub with revolving arms. These were nine feet in diameter and were used to settle the amalgam, quicksilver, and heavy metals. The settler takes the charge from the pans. There are four arms, or sweeps, hooked to the center cone, each having two adjustable wooden shoes shaped like cultivator shares that reach within three-fourths of an inch from the bottom, plowing up the sands. The material settles at a different rate from light to heavy. There are drain holes at different heights on the side of the settler to draw off the processed material. The heavy solution at the bottom is discharged to an agitator or dolly tub, figure 34. The agitators, made of wood, were from eight to 20 feet in diameter and 2.5 to four feet in depth. The agitator has six to eight arms that almost reach the bottom and rotate at 10–20 revolutions per minute. The agitator is used to recover what the other mill machinery did not.

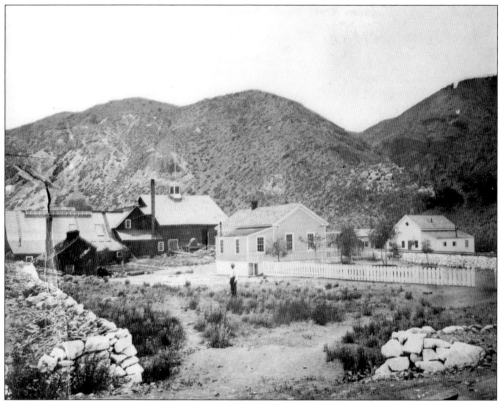

Houses at the Merrimac Mill can be seen in the above photograph. The mill was sold in 1869 to the Union Mill & Mining Company, which owned it until 1910, when it was sold to the Western Smelters Corporation. In the 1870s, the mill contained 20 stamps, 13 pans, and 6 settlers and crushed 45 tons of ore per day. In 1866, the mill was used for political addresses for the Brunswick Precinct. (Courtesy of Stephen E. Drew.)

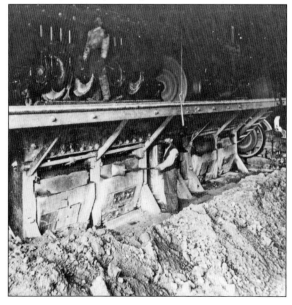

At left is the interior of the mill, featuring the stamp batteries. There were five stamps per battery. The stamp stems, which can be seen at the top left, were 3.5 inches in diameter and 14 feet long. The stamps weighed 800 to 900 pounds each. There appears to be a lot of material in the front of the stamps that could be cleaned up to recover values that splashed out. (Courtesy of the Nevada Historical Society.)

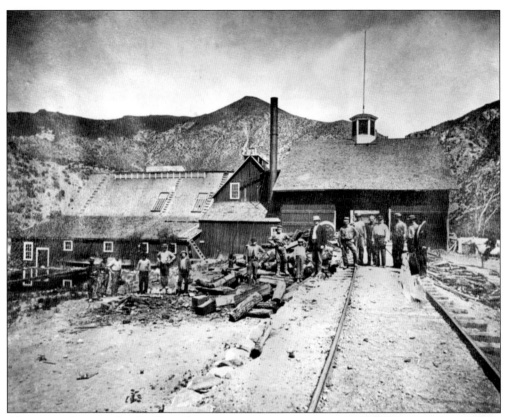

Above is a photograph of mill employees in 1880. The tracks going into the mill were used by the railroad to dump the ore from the Comstock mines. The mill employed 15 men in 1862, two amalgamators, one blacksmith, four carpenters, seven laborers, and one millwright. By 1876, the number of employees had increased to 20 men. In its later years, there were only four employees to watch the mill. (Courtesy of the Nevada State Railroad Museum.)

Henry Marvin Yerington was born in Colborne, Canada, in 1829 and came to Nevada in 1863. He was involved in the Merrimac Mill as superintendent and owner. Yerington sold the mill and worked for the Virginia & Truckee Railroad as superintendent and vice president. He was also involved in the building of the Carson & Colorado Railroad. He passed away on November 25, 1910. (Courtesy of the Yerington Family Collection.)

Pictured here after November 1941, the mill is mostly gone. The Virginia & Truckee Railroad tracks have been pulled up, and it is now a road. This road could be driven by four-wheel drive from Deer Run Road to Mound House until the new Virginia & Truckee tracks were put in, blocking the exit to Mound House. (Courtesy of the Nevada Historical Society.)

Pictured here is the stone quarry across the river from the Merrimac Mill. The stones used at the Merrimac were quarried here. There are remnants of the wooden foundation with iron pegs that held the machinery that lowered the stones down to river level so they could be transported to the mill. The stone has a reddish color, and the quarry can be hiked to. (Courtesy of the Nevada Historical Society.)

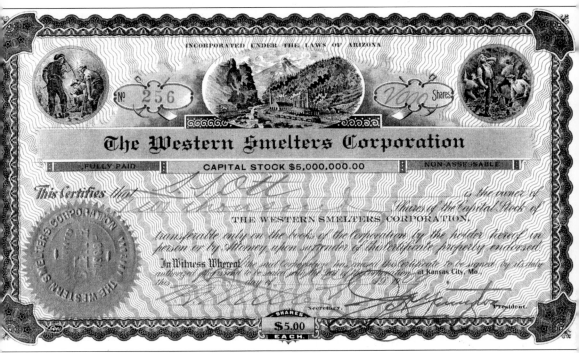

The Western Smelters Corporation was incorporated in 1908 by James Yerington (son of Henry Yerington). James was president, and W.F. Miller served as secretary. After a decision by Arizona in 1909 that meetings of Arizona corporations had to be held in that territory, Yerington dissolved the Arizona corporation and reincorporated it in Nevada on July 15, 1909. Stock certificates for the new corporation may never have been issued. The original stockholders were James A. Yerington, E.B. Yerington, James W. Boileau, W.F. Miller, and P.B. Ellis. The company was to build a large smelter on the property adjoining the Merrimac millsite. The Virginia & Truckee Railroad laid two parts of a balloon track around the north and south sides of the smelter, but it was never completed. This track was to be used for the delivery of supplies and ore. The company purchased the Brunswick Mill so it could use the Brunswick's dam and ditch for water power. After the purchase, the company started cleaning up the Brunswick site to recover lost values that may have been there.

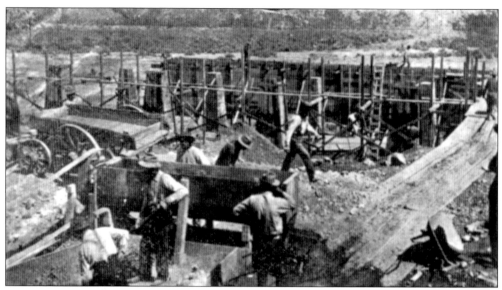

On May 1, 1910, workers started putting in concrete piers and forms for the retaining wall of the main building, which was to be 250 by 63 feet and divided into sections: laboratory and assay office (21 by 21 feet), chemical room (26 by 32 feet), furnace room (14 by 21 feet), scale and office room (14 by 21 feet) with a traveling crane, copper converter room (63 by 105 feet), furnace space, settlers, and fan blowers (63 by 105 feet), and an annex (40 by 63 feet).

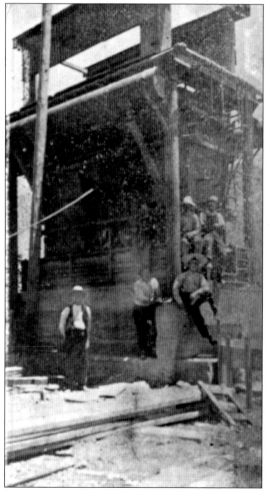

Men are pictured here working on the 250-ton steel water-jacket furnace made by Allis-Chalmers. The big steel water-jacketed furnace consisted of 14 jackets, with 18 tuyeres measuring 160 inches by 44 inches. A tuyere is a tube through which air or oxygen is blown into a furnace under pressure from a blowing engine. This causes the fire to become hotter than it would be otherwise, enabling metals to be melted.

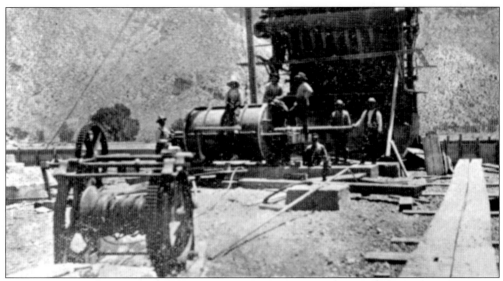

Pictured here are workers erecting a Connelsville blower, made in Connelsville, Ohio, which weighed 18 tons with a displacement of 100 feet of air per minute. In 1910, the annual report noted the blower "is perfect in every respect and of the best made in the United States. The blower is a vertical type with 40 inch diameter cylinders and a 42-inch stroke, turning at 80 revolutions per minute driven by two 250 horse power electric motors."

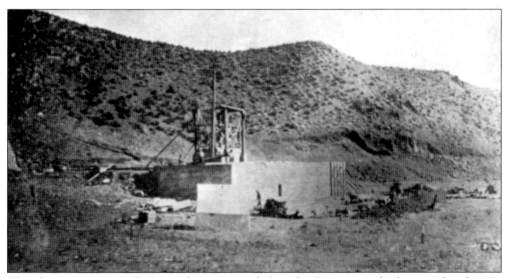

The above concrete wall shows the entrance below the furnace to the hot-air chamber. In constructing the foundation, the builders allowed room for a crucible at the bottom of the furnace, which gives the furnace an increased capacity. The crucible castings were made at the Virginia & Truckee shops at Carson City; they weighed some 11,000 pounds and were lined with fire brick. The main stack was approximately 1,000 feet tall and 12 by 14 feet in diameter.

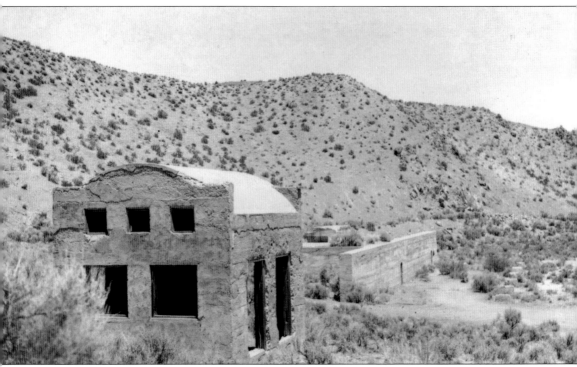

The remains of the smelter's concrete power house are pictured here in the 1950s–1960s. The electrical power for the smelter was to be brought from the Floriston, Nevada, power-generating plant on the Truckee River. This plant was powered by water from the Truckee River and supplied the power to all of western Nevada at the time. In the background one can see what is left of the main building foundation. The power house has since been demolished by Carson City, and the large main building foundation has shown deterioration. The Virginia & Truckee track-spur grade remains and shows exactly where the railroad line was in relation to the smelter, visible in the right center of the photograph. The large unfinished concrete work of the smelter remains today, but in time it will be gone. The smelter was also known as the Brunswick Smelter and Yerington Smelter. James Yerington got involved in a gypsum plant in California in 1912. (Courtesy of the Nevada State Museum.)

At right is an 1877 Wheeler map showing Copper Canyon, where the Copper Canyon/Blue Canyon Mill resided. Built in 1862 at a cost of $15,000, the mill was owned by W.W. Van Vleet, E.P. Tucker, George W. Moore, and E.C. Clark, who also owned the Yellow Jacket Claim on the Gold Hill Ledge. The water was brought through a ditch 600 feet in length. The building was 60 by 40 feet and contained 10 stamps. Managed by Henry Shadel, this mill was short lived.

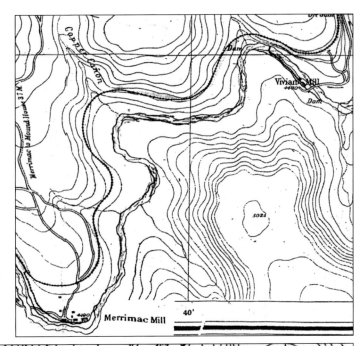

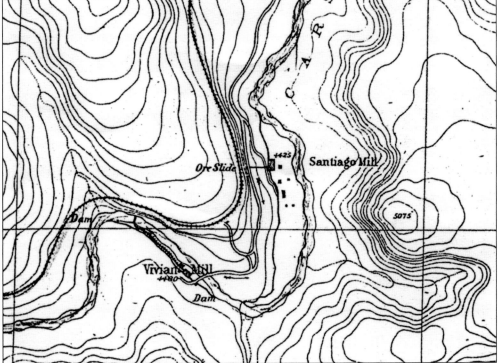

The Vivian Mill and Dam is featured on this map from 1877. The dam is to the left, as are the Virginia & Truckee Railroad tracks. The mill was on the south side of the river, so a rock chute was built next to the railroad tracks, and an isolated 19.5-inch railroad track across the river facilitated in transporting ore to the mill. Built in 1860 by C.B. Barstow, the operation was owned by a Mr. Henson and Joseph Woodworth.

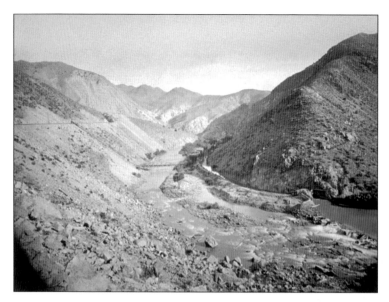

In the photograph at left, the Vivian Mill's rock and stone dam is shown to the right with the 1,100-foot ditch leading to the mill. The water drove a central discharge turbine 7.5 feet in diameter. The mill was washed away in the 1861 flood and rebuilt in 1862 at a cost of $75,000. It was owned by Sperry and Company. James Sperry lived at the mill.

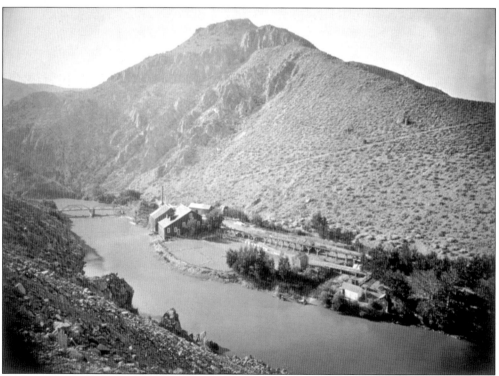

Above is the Vivian Mill with a tailings pond in the front. The river is backed up by the Santiago Mill dam. The bridge for transporting supplies and people to the mill is at the left. The steel pins for this bridge can be seen today in the rock at the edge of the river. The mill was owned by Ruhling and Company and superintended by C.B. Barstow in 1863.

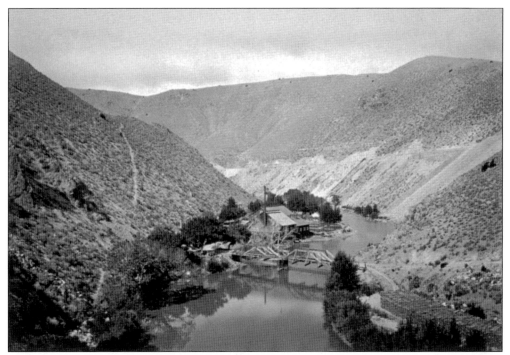

Above is a view of Vivian Mill from the east. A better view of the supply bridge is given. To the right is cordwood stacked for the mill, which burned about three-quarters of a cord a day. In 1864, the mill was owned by Peter Frothingham, who added a house. It had 16 stamps weighing 750 pounds each, eight Wheeler pans, four settlers, and one agitator.

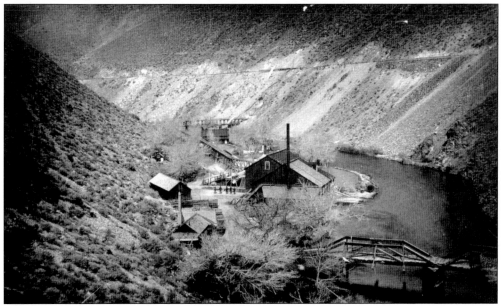

The mill was sold to the Union Mill & Mining Company in 1869, then to the Vivian Mill Company, then back to the Union Mill & Mining Company with Abram "Abe" Edgington as superintendent. In 1880, the mill was sold to Robert F. Morrow, who owned it until at least 1903. The mill capacity of 40 tons per day stayed the same throughout its lifespan.

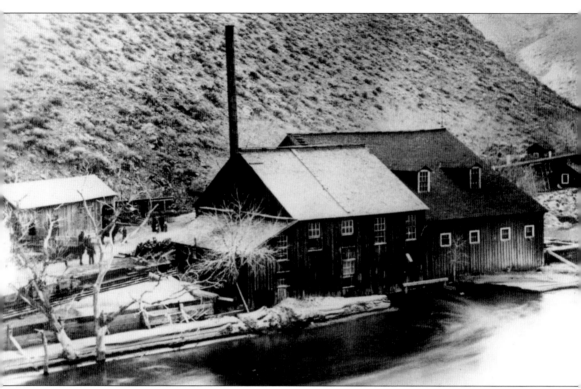

This close-up of the mill building demonstrates just how close to the river the mill was. It was feared the mill would be washed away by floods many times over its life. During its years of operation, the mill processed ore from the Ophir, Trojan Gold and Silver Mining Company, Overman, Crown Point, Belcher, Yellow Jacket, Hale & Norcross, Imperial, Confidence, Consolidated California and Virginia, and Kentuck Mines. The ore shipments ranged from 160 to 320 tons per week. In 1893, one week's shipment from the Consolidated California and Virginia Mine had a gross value of $12,477.14, averaging $15.33 per ton. The ore was worked to 92 percent of its assay value, which was very high for the time. The amount of mercury used for the month at the mill was around 417 pounds, or six canisters. The land the Vivian Mill sat on was owned by Nancy Bourke, a biracial Sioux, when the mill was built. She received the land from the government but sold her interested to Peter Frothingham for $2,000. (Courtesy of the Nevada Historical Society.)

No. 178 Virginia, Nev., _____ 187_

Agency of The Bank of California,

Pay to _____, or Order

_____ Dollars,

$ _____

For Vivian Mining Co.

The Vivian Mining Company owned the mill for a short time in 1870. The mill equipment remained about the same throughout its life. The ore originally came from the owners' mining claims in Gold Hill. In 1887, the Crown Point Mine was shipping ore to the Vivian, but the ore became too low grade to process profitably, so the management of the Crown Point relinquished the mill to the Overman Mine.

Augustus Cutts, born in Maine in November 1837, moved to Nevada before 1880 and was a wood dealer. He became the superintendent of the Vivian Mill in 1881 and lived on site. He also worked at the Santiago Mill in the late 1800s. The mill employed seven to 17 men, with only five remaining in 1900. In 1910, Cutts was a blacksmith at the age of 72. (Courtesy of the Nevada State Museum.)

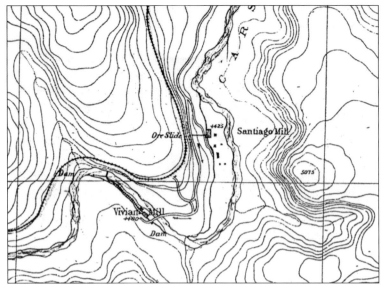

The Santiago Mill and its outbuildings are pictured here in 1877. The solid stone dam for the water flume and ditch, which was half a mile long and 15 feet wide, is shown just below the Vivian Mill. The rock chute in which the ore transported by the Virginia & Truckee Railroad was dumped is evident, with the holding bin below.

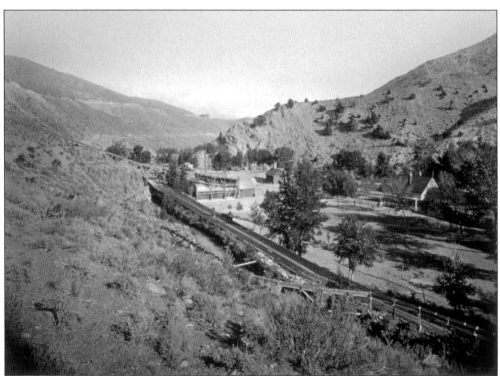

Above, the Santiago water flume is shown in the foreground with the mill in the background. The Santiago Mill was also known as the Zepher Flat Mill and the Stewart and Hennings Mill. The mill was built in 1862 by William M. Stewart, John Henning, Jas Morgan, and C.F. Wood. The main building was 160 by 60 feet with a stone office building of 30 by 40 feet. The construction cost was $50,000.

At right is an overview of the Santiago Mill. The turbine wheel that supplied the power to run the original 16 stamps and Wakelee pans using the sagebrush process was seven feet in diameter and weighed 7,000 pounds. The ore came from the owner's claim in Gold Hill. The mill was sold to H.H. Raymond and William Thompson Jr., with William S. Rowe as superintendent in 1863.

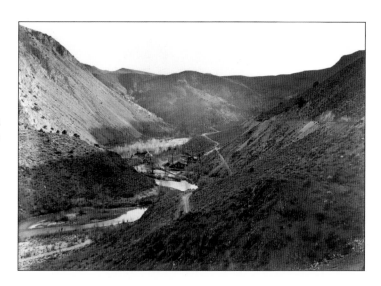

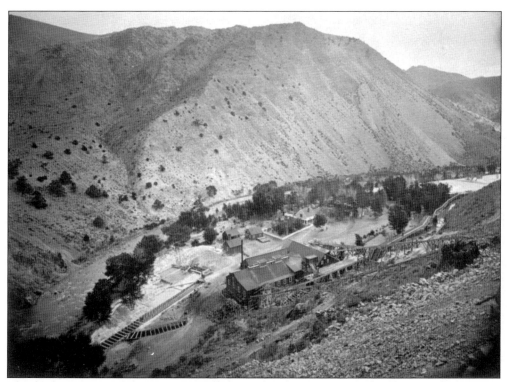

This bird's-eye view of the Santiago Mill shows the placement of the buildings, with the water flume coming in from the right. The Carson River is in the background. In 1865, the mill had expanded to 24 stamps, 14 pans, and seven separators. Supplies on hand at the mill were four horses, one buggy, 100 cords of wood, 4,000 pounds of quicksilver, 4,800 pounds of salt, acids, and two wagons.

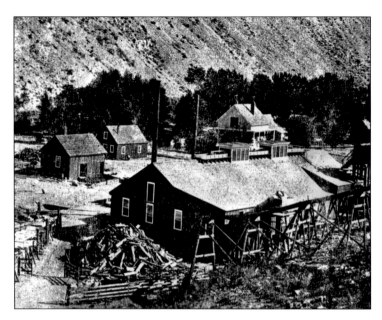

Similar to the Vivian Mill, the Santiago Mill's land was owned by William Bourke and Nancy Bourke, biracial Dakota Sioux, when the mill was built. They sold it to the Santiago Mining Company in 1867 for $1,088. Donald C. McKay was superintendent through 1884. In 1870, the mill was sold to the Union Mill & Mining Company, which owned the mill at least through 1910.

Above is the billhead for a screen order for the Santiago Mill. Screens were used at the outlets of the stamp batteries to control the fineness of the ore crushed. The Comstock ore had to be crushed to a certain fineness to liberate the gold and silver. In 1870, the mill was upgraded to 34 stamps, nine pans, and 18 settlers. In 1893, it had 38 stamps and 16 concentrators. The billhead is signed by W. H. Armstrong, who was superintendent at the time.

Shown at right are the ruins of the stone office building at the Santiago Mill. The mill employed 16 men most of the time. Everything but a small part of the rock wall that was the Santiago Mill is gone. There was a murder at the Santiago Mill. In 1912, the body of a man was found in an arrastra pan buried head down in about four feet of sand with his feet sticking out. (Courtesy of the Nevada Historical Society.)

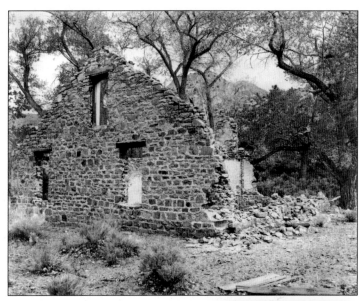

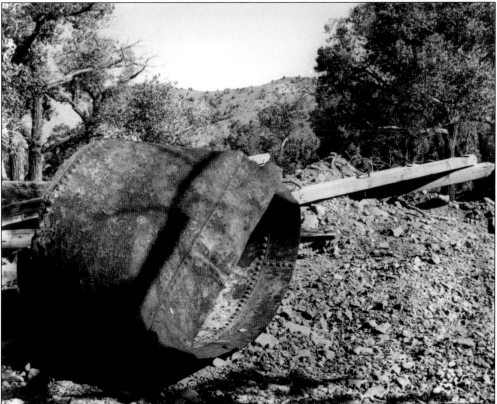

Pictured here is a bucket remnant from the Santiago Mill. A watch and a slip of paper were found on the body. The paper had the address of a woman living in Salt Lake City. The mill was burned down to hide the evidence. A newspaper was found in the dead man's cabin dated December 20, 1911, suggesting the murder was committed around that time. The man was never identified. (Courtesy of the Nevada Historical Society.)

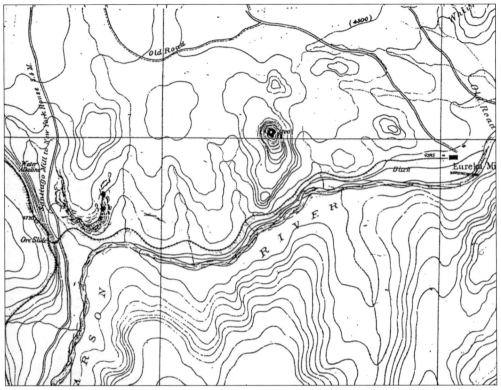

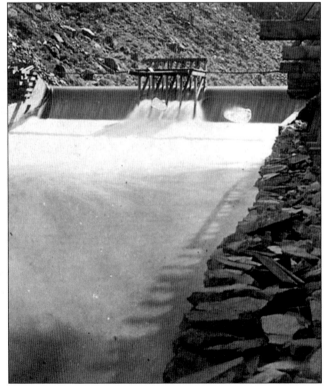

The Eureka Mill was built approximately a mile from the Virginia & Truckee Railroad tracks, as can be seen on the map. There was an ore slide where the railroad dumped the ore, and it was then transported to the mill. The flume and ditch can also be seen. Before the railroad was built, the ore was brought to the mill by wagons.

Eureka Mill, built in 1861, was close to two miles below the Santiago Mill. The 26-foot-high, 200-foot-long dam was made of stone and 14-inch-square timbers and arched upstream. It backed the Carson River water up about a mile. To build the dam, it took 400,000 feet of timber. The mill machinery was driven by a Leffel Turbine Wheel, 52 inches in diameter with a 10-foot pulley.

The 4,200-foot-long wooden flume that supplied the water to the mill was 12 feet wide and 4.83 feet deep. The water from the dam and flume was also used to run the San Francisco Mill, but the Eureka had the priority. The agreement signed in 1862 by both companies stated that the dam would be built and maintained by both.

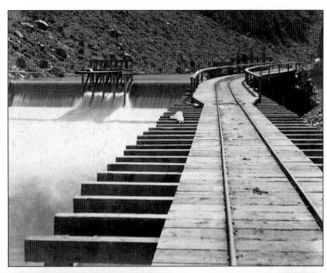

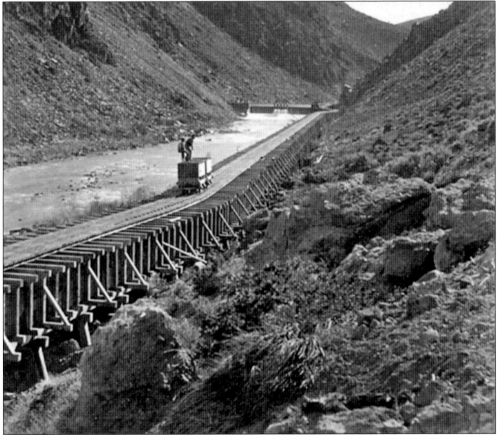

The flume was covered and of substantial strength to carry horse-drawn cars carrying ore from the rock chute where the Virginia & Truckee dumped the ore to the mill. The cars rolled by gravity to the mill and were pulled, two cars at a time, back to the ore chute. The cars were originally pulled by horses, but this was a slow process. Note men standing on the ore cars with the massive dam in the background.

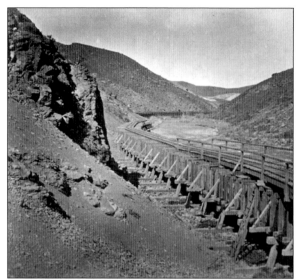

The flume length can be seen as it meanders down the canyon. A road along the flume was also to be built under the agreement. It appears that a road is coming down the hill at the left. This might be the road that was stated in the agreement. The owners of the Eureka Mill in 1862 were M.S. Hurd, Peter G. Bossel, Fred Dunker, and the estate of P.C. Braum.

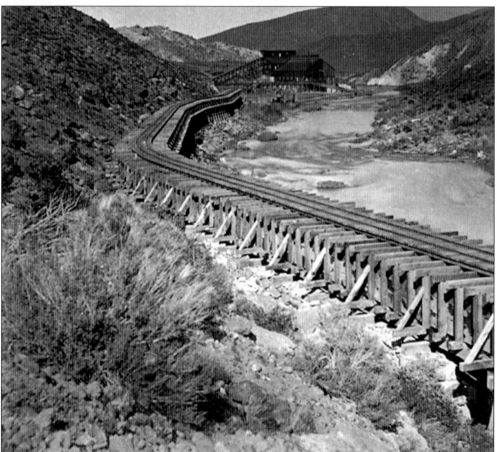

The Eureka Mill is pictured here in the background with the Carson River on the right, which looks like it is in a very low state. The water rights for the mill were filed again in 1889 by the Comstock Mill and Mining Company, which owned the mill at that time.

At right is the layout of the Eureka Mill, with residences in the foreground and the mill in the background. To the left of the mill is a wooden trestle where the ore cars were lifted to dump the ore in the top of the mill. The water entered the mill more toward the bottom. Most of the houses have disappeared along with the flume and mill.

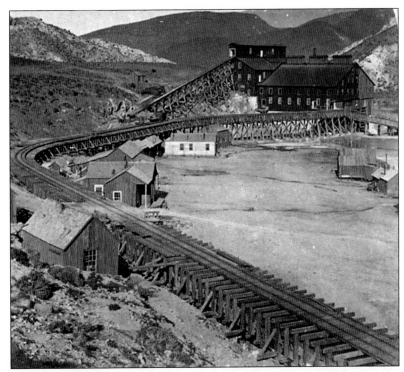

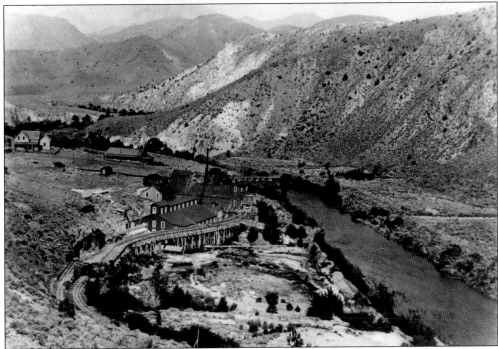

In this image of the Eureka Mill, the superintendent's house is at center left with the mill in the foreground. The main mill building contained 20 stamps, four arrastras, and an amalgamating department with 42 Hungarian bowls, 12 copper concentrators, 6 flues, and 2 Varney pans, was 75 by 80 feet, and was built in 1861. The mill was using what was known as the Hurd's process.

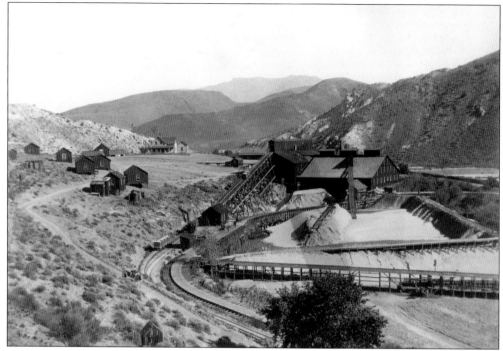

Four ore cars loaded with ore are to the left of the flume ready to go up the incline trestle, which has two ore cars on it, ready to dump the ore into the mill. The milling process used gravity to work the ore, so the raw ore was dumped in the top, where it first went through rock crushers to crush it to the correct size for the stamp batteries.

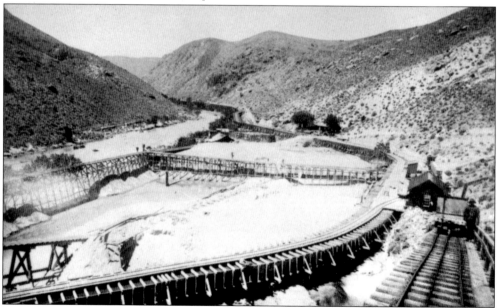

An ore car at the right ascends the 370-foot trestle, which raised the ore to a height of 50 feet to dump into the top of the Eureka Mill. The cars were pulled up by a cable that can be seen in the center of the tracks. The immense mill operation can be seen with all the other trestles and outside machinery.

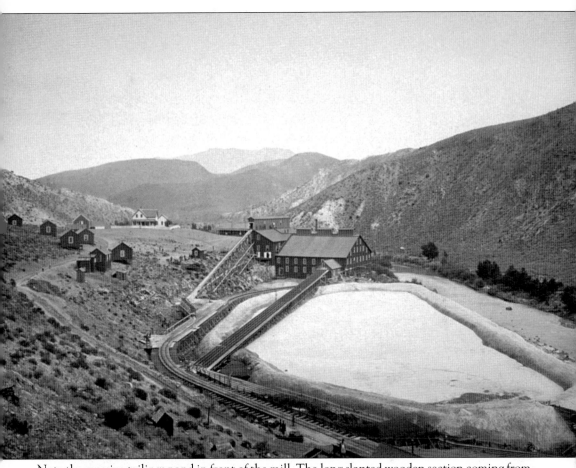

Note the massive tailings pond in front of the mill. The long slanted wooden section coming from the small building is a 1,200-foot-long sluice where the discharge of the mill went to try to catch any unrecovered values. The mill was built by M.S. Hurd, C.T. Wheeler, and Ferdinand Dunker at a cost of $100,000 and was known as the Carson Eureka Mill. The mill was sold at a sheriff's sale in 1869 to Abraham Klauber for $34.10 plus back taxes of $39.56. Thomas Sunderland and W.S. Wood obtained the land and water rights to the Eureka Mill in 1871 and sold them to the Union Mill & Mining Company in 1872. The mill was rebuilt for $200,000 and was known as the New Eureka Mill. M.R. King was the superintendent. In 1878, the mill was purchased by the Nevada Silver Mining Company for $175,000 to process tailings and slimes. The next owners were the Sierra Nevada Silver Mining Company in 1879 and the Comstock Mill and Mining Company in 1886.

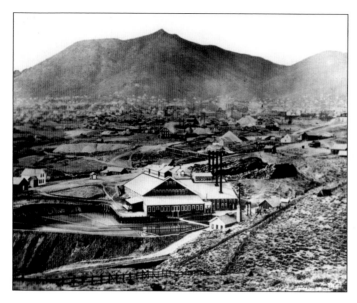

From an annual report of the Consolidated California and Virginia Mining Company for the year ending September 30, 1889, the Eureka Mill worked 53,980 tons of ore, which produced $641,655.21 worth of gold and $717,194.47 in silver, totaling $1,358,849.68. The yield of bullion per ton was $11.887 (gold) and $13.267 (silver), and total yield per ton was $25.146. The assay value of the ore per ton per battery samples was $29.694. (Courtesy of Stephen E. Drew.)

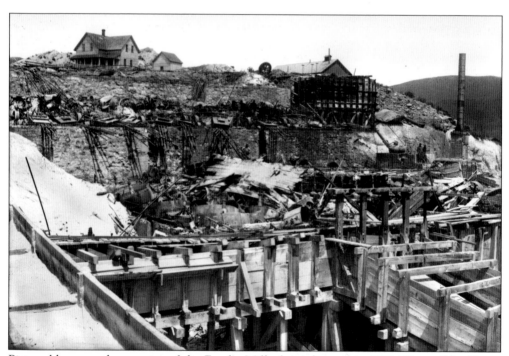

Pictured here are the remains of the Eureka Mill after it burned in 1893. The mill had been rebuilt in 1890 with a main building measuring 120 by 180 feet housing 60 stamps, 16 large settling tanks, 24 pans with eight-ton capacities, 6 settlers nine feet in diameter, 2 agitators, and 1 clean-up pan. The tailings reservoir held 860,000-plus tons of tailings. (Courtesy of the Nevada Historical Society.)

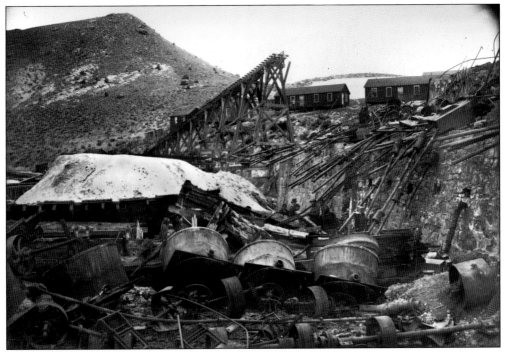

Above is another photograph of the aftermath of the fire. The trestle that the ore cars traversed to the top of the mill still stands in the center of the image. The stamp battery rods are lying on the ground to the right of the trestle. The mill had also been used to process tailings from the Nevada Mill in Virginia City before the fire. (Courtesy of the Nevada Historical Society.)

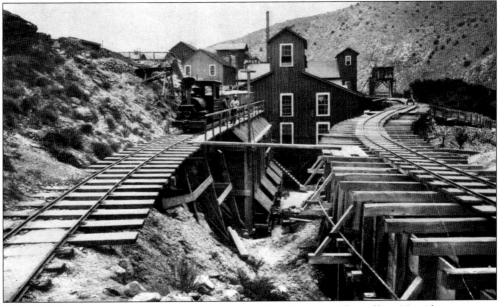

The mill was rebuilt in 1897 as a cyanide mill. The first cyanide mill in Nevada to process Comstock tailings was built at Silver City by R.D. Jackson. The first two large cyanide plants were the Delamar Plant at Delamar, Nevada, and the Eureka Cyanide Mill. The Eureka Cyanide Mill was built by A.J. McCone. (Courtesy of Stephen E. Drew.)

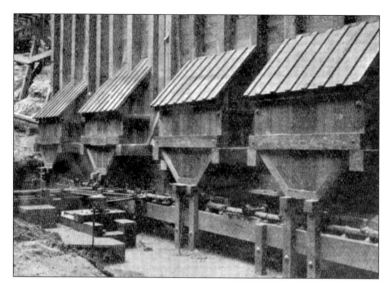

These are the bins that the tailings were dumped into when they were delivered to the mill by the Eureka Railroad. The bins had an opening at the bottom, and the tailings were released to the conveyor shown at the bottom. The bins were substantial, but time has taken its toll, and nothing remains today. (Courtesy of the Nevada Historical Society.)

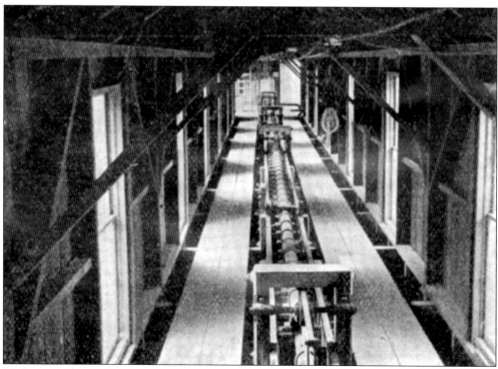

McCone used a mechanical conveying appliance of his own design to transport the tailings over the vats below for processing, as shown here. The tailings were run through sluices after they were processed to recover as much as possible. The mill was kept very neat and clean to keep impurities from hampering the recovery process. (Courtesy of the Nevada Historical Society.)

The vats in the background were where the tailings and the cyanide were mixed. Cyanide dissolves the gold and silver into a solution, a process that could take a few days depending on the size of the material to be dissolved. The process is sped up with heat. This photograph was taken by a man named William E. Cann, who was a druggist in Reno. (Courtesy of Stephen E. Drew.)

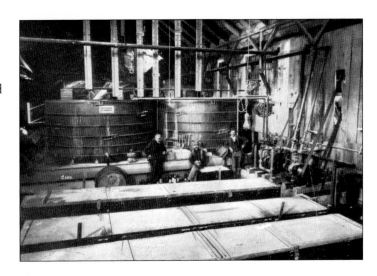

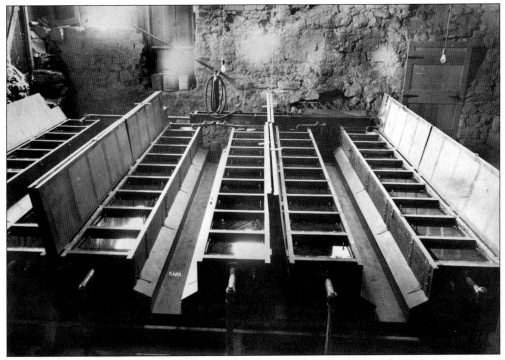

The solution containing the cyanide and dissolved gold and silver was known as a pregnant solution. When the mill man felt all the gold and silver had been dissolved, the solution was run through boxes containing either zinc or carbon, which reacts with the dissolved gold and silver, turning it into its original state. The Eureka used zinc in these boxes. The precipitate was then run through a filter. (Courtesy of Nevada Historical Society.)

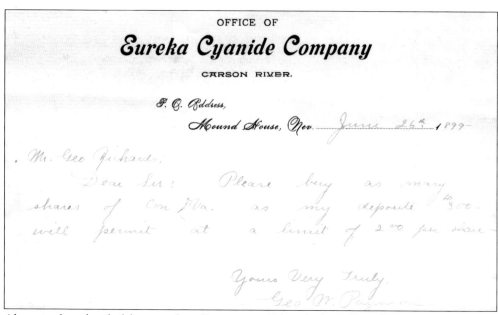

OFFICE OF

Eureka Cyanide Company

CARSON RIVER.

P. O. Address,

Mound House, Nev. _____ June 26th 1899

Mr. Geo Richards,

Dear Sir: Please buy as many shares of Con Va. as my deposite $300. will permit at a limit of 2.00 per share

Yours Very Truly,
Geo W. Payne

Above is a letterhead of the cyanide mill company. Although the mill was known as the McCone Mill, its real name was the Eureka Cyanide Mill, owned by the Eureka Cyanide Company. This company owned the mill until around 1906, when the mill shut down for good. The mill was processing tailings from around the Carson River as well as the Comstock.

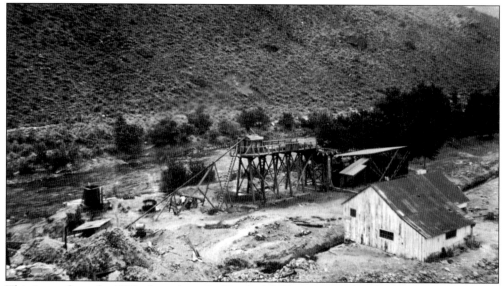

This image from the 1920s shows how the Eureka Mill has retreated; only this trestle and house remained when Thurman Roberts took this photograph. It is unknown what this trestle was used for. By 1997, the trestle as well as the buildings in this photograph had disappeared. (Courtesy of the Nevada Historical Society.)

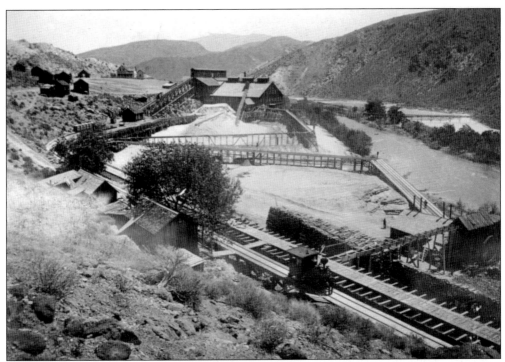

The horses that pulled the ore cars were replaced in 1880 by a steam-powered railroad engine. The railroad engine was too heavy for the wooden flume and broke through it. A new 1.1-mile road bed was constructed for the 30-inch-gauge railroad leading from the ore bins to the Eureka Mill.

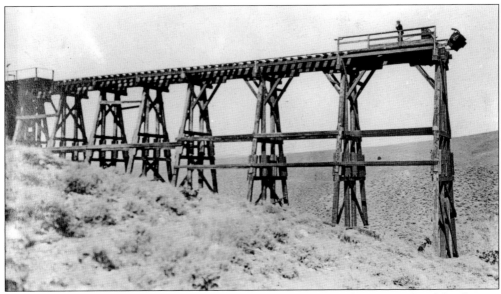

Shown here is the Virginia & Truckee trestle that was a spur off the main railroad for the cars delivering the ore to Eureka Mill. Many of these trestles worked on gravity to keep from running an engine on them. There are still remnants of this trestle today, which are the sawed-off stubs of the main supports. (Courtesy of Stephen E. Drew.)

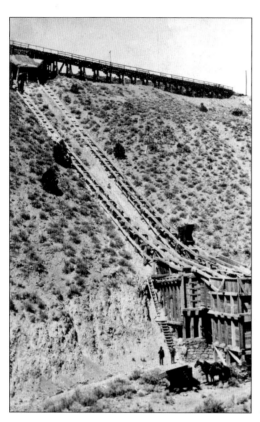

In 1872, a rock chute from the Virginia & Truckee trestle specially built to deliver ore to the Eureka Mill was built. The chute was 350 feet long, measured 14 feet, three inches wide, and had planks separating the ore. The bottom was lined with iron to help the ore slide easier. It was on an angle of 36 degrees. (Courtesy of Stephen E. Drew.)

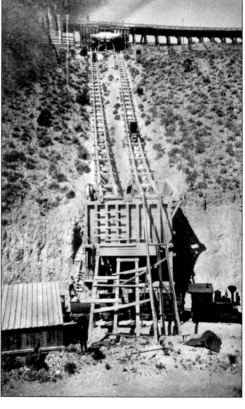

Pictured here in the 1880s, the ore bin at the bottom was 18 feet wide and 16 feet high, separated into two parts so it could hold two kinds of ore. It had a capacity of 1,000 tons. The rock chutes were replaced by an incline tram that had two cars side by side. The weight of one would pull the unloaded one back up to the top. (Courtesy of the Nevada Historical Society.)

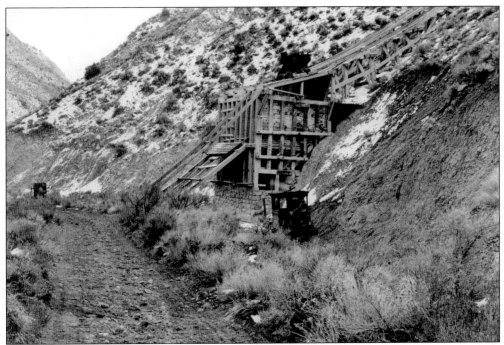

This is a close-up of the tram ore car, which has just dumped its load into the ore bin. These small ore cars were connected by a cable. The original railroad line from the ore bin to the Eureka Mill was built in 1872 by the Union Mill & Mining Company for $20,000. The rock chute was replaced by an incline tram. (Courtesy of the Nevada Historical Society.)

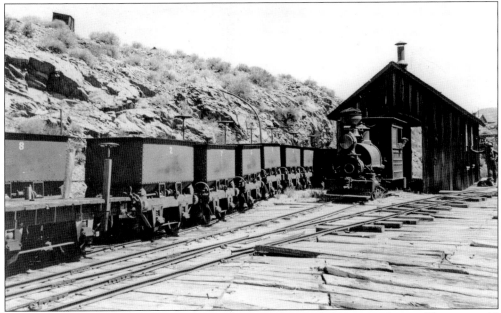

The Eureka Mill Railroad cars lined up with the ending and the engine house. There were 10 ore cars and two flatcars used on the original line. In 1887, the Eureka Mill purchased a H.K. Porter 0-4-0T engine that weighed six tons. The ore cars could carry five tons of ore or tailings each. (Courtesy of Stephen E. Drew.)

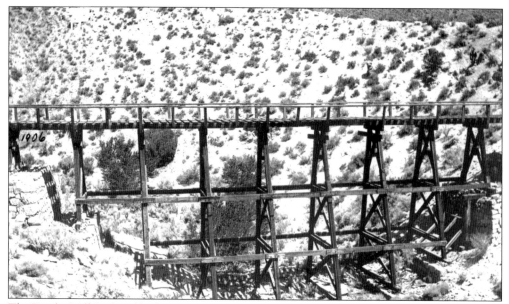

The Eureka Mill Railroad had to cross two ravines to get the ore and tailings to the mill, so trestles like this one were built. This trestle was built of wood and was similar in design to the Crown Point Trestle in Gold Hill used by the Virginia & Truckee Railroad. Only the rock abutments at each end of the trestle are visible today. (Courtesy of the Nevada Historical Society.)

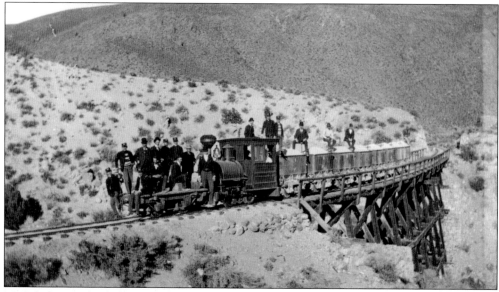

McCone's cars, loaded with tailings, are pictured here on March 15, 1900. Students from the University of Nevada pose (some in tails no less) for their senior-class photograph with the Eureka Mill train. When the engine was no longer needed at the Eureka Mill, it was used in the construction of the Almanor and Butt Lake Dams. It was discovered in 1996 after 82 years at the bottom of the lake and has been restored.

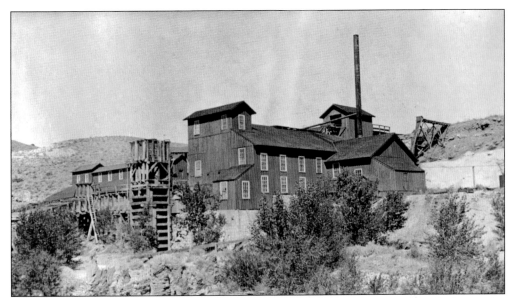

In the above photograph, taken in 1905, the Eureka Mill is starting to decay, with the trestles and iron having already been removed. The wood was sent to Virginia City and neighboring towns for firewood, as there was a shortage of kindling. The machinery in the mill went to the scrap dealers. The tailings were purchased by a Chicago group and processed at the Mexican Mill. (Courtesy of the Nevada Historical Society.)

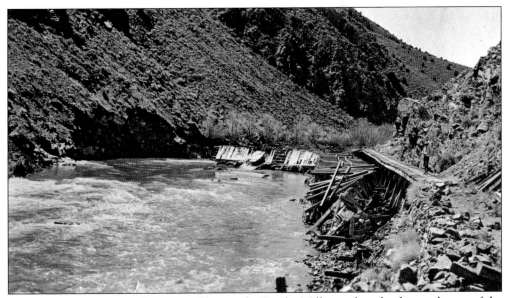

March 1907 brought another serious blow to the Eureka Mill complex; the dam and parts of the flume and railroad track were destroyed by a flood. Other dams and mills, along with tailings, reservoirs, and flumes, were destroyed in the flood. The mill complex continued its decay. (Courtesy of the Nevada Historical Society.)

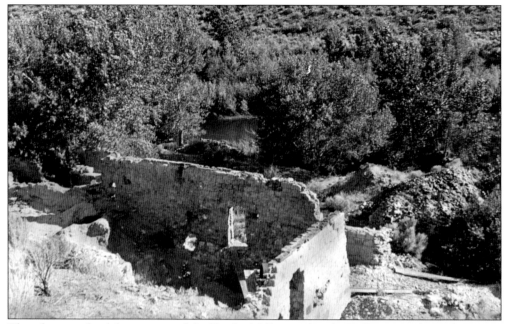

This photograph of the remains of the Eureka Mill was taken by William Wright in the 1940s. The stone structures were the longest to survive. The wood is gone, either taken or fallen down and washed away in the floods that occurred after the 1907 flood. The rock work of the day was substantial and really a work of art. (Courtesy of the Nevada Historical Society.)

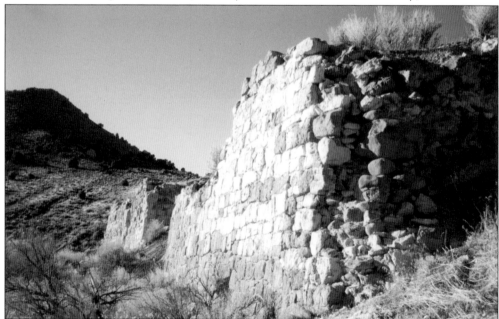

Above is a photograph of the rock work at the Eureka Mill in 1997. It has weathered the test of time, lasting over 100 years. These walls are on the side of the mill facing the Carson River. The collapsed remains of a few of the wooden buildings remain, one being the superintendent's house. This mill is very hard to get to on a four-wheel drive road, and it is not advisable for the faint of heart.

Three

MILLS DOWN THE CANYON

The mills in this stretch of the Carson River were for the most part small mills and not as easy to get to. In addition to their inaccessibility, most of these mills were very short lived, and as such, there are few images of them. The first mill in this section was the San Francisco Mill, which was to the east of the Eureka Mill and used water from the Eureka Dam and flume. The mill was in operation in 1862 with 20 stamps and was owned by Charles Itgen, A.H. Dosher, Charles McWilliams, and William C. Divoll, with Divoll as superintendent. The building was 50 by 60 feet. Although water-powered, the mill used steam to heat the water used in the stamp batteries and for the Hatch process, which was said to yield 20 to 40 percent more ore values than other processes. In 1865, the mill was owned by Charles Schad, A.H. Dosher, a Mr. Bremen, and Charles Itgen, with Charles Schad as superintendent. Next in line was the Franklin Mill, followed by the Barton and Company Mill, built in 1862 by J.N. Barson, John Barton, J.R. Brett, and Levi Hite. J.N. Barton was the superintendent. It had four arrastras and could process eight tons of ore per day. The water to run the machinery was transported 1.5 miles from the dam.

The Sprouls Quartz Mill was next to the Barton and Company Mill. It was known as Sproul and Company's Mill or Excelsior Mill and was built in 1862 by C.C. Goldwin and Levi Hite, with J.R. Brett as the superintendent. It ran 10 stamps and 20 Hungarian pans and cost $5,000 to build. The dam was 175 feet wide to capture the water to run the mill. It is noted that in 1875, the mill was running tailings and was in very close proximity to the Kustel and Winters, also known as the Aurora/Carson River, Hasting and Woodworth, and Ophir Mills. A Mr. Moshimer also had a mill adjoining the Carson River Mill.

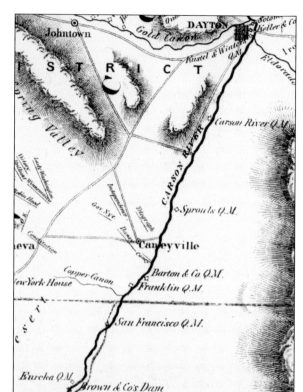

This 1862 Bancroft map shows the location of the mills between the Eureka Mill and the town of Dayton. The old Ophir was built in the early 1860s, and the New Ophir was built in 1866. The Hasting and Woodworth was built in 1860, and when Hasting sold his interest, it was known as Woodworth and Walsh. Note the mills were built on both sides of the river.

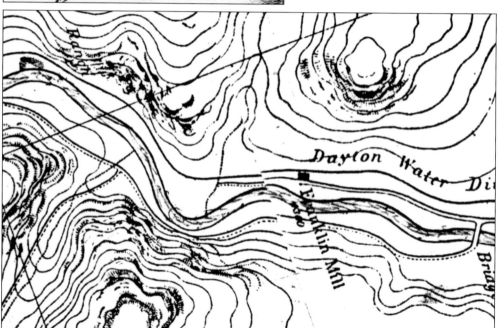

The Franklin Mill was located on the north side of the river approximately two miles above the town of Dayton. The dam was built of stone 20 feet wide at the base and 10 feet wide at the top. The water was conducted to the mill through a flume seven feet wide and half a mile long, which drove a center discharge wheel 6.5 feet in diameter.

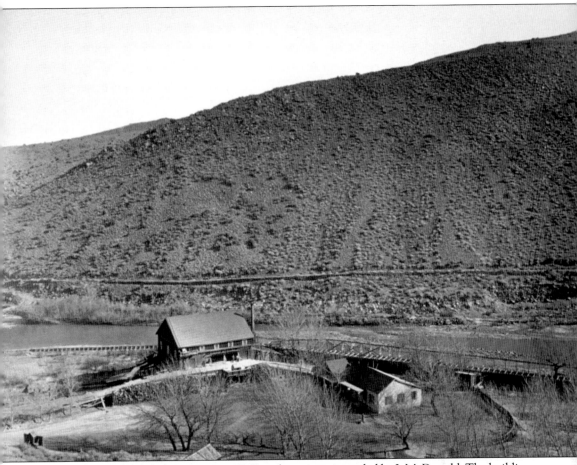

The Franklin Mill was in operation in 1862 and was superintended by J. McDonald. The building, measuring 30 by 60 feet, contained 10 stamps and two arrastras, with shaking tables and Hungarian riffles. The mill cost $60,000 and was intended to crush ore from the Daney Mine, which was 1.5 miles from the mill. In 1865, Treglone & Company owned the mill, and William Jones was superintendent. William Sharon purchased the mill in 1866 and in 1868 deeded the mill to the Union Mill & Mining Company, which owned it through 1911. In 1866, the mill was upgraded to two Wheeler pans, two Hepburn pans, and two settlers with a crushing capacity of 500 tons per month. In 1867, Samuel L. Chapin, who was part owner, sold his interest to Sharon. In 1879, D. McKay was given the right to process tailings at the mill, which he was to repair for working said tailings. In 1880, the mill had two amalgamators, two blacksmiths, two blanket sweepers, one carpenter, and eight laborers.

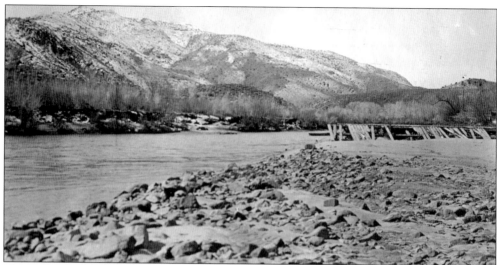

Shown here is the Franklin Dam after the flood in March 1907. In 1879, the mill worked 1,600 tons of tailings with a value of $7.74 per ton and a gross yield of $12,395.23. A report in 1893 indicated the dam was in bad decay, and it appeared as if the mill had not been used for two or three years. The mill appears to have been used sporadically throughout its life, falling into disrepair and then being rebuilt. (Courtesy of the Nevada Historical Society.)

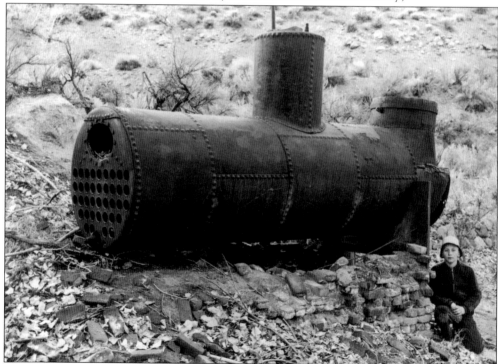

Pictured here is the old boiler from the Franklin Mill, which was ultimately cut up and scrapped. The boiler, like the other equipment, was made by Booth & Company of Marysville, California. The mill was upgraded throughout its life, and in the early 1870s, the 20 stamps were crushing 40 tons of ore per day. The site today is flat with some sagebrush and trees. (Courtesy of the Nevada Historical Society.)

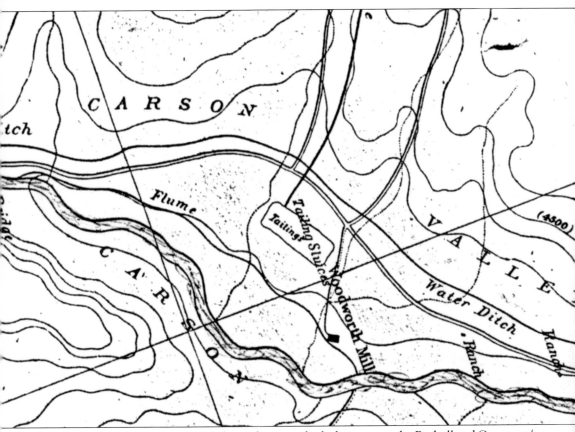

This layout of the Woodworth Mill shows the water ditch that went to the Birdsall and Carpenter/ Douglas Mill in Dayton. The tailings sluice's length can be seen by the dark line from the mill going to the north. The mill was built in 1864 at a cost $75,000, and in 1869, the mill contained 24 stamps and 12 pans and had a capacity of 40 tons per day. The 1880 census lists 31 employees at the mill: two amalgamators, one blacksmith, one carpenter, two engineers, and 25 laborers. The mill was owned by James Graham Fair and John William Mackay's Pacific Mill and Mining Company in 1871 and was overhauled under supervision of S. Fountain. A new turbine wheel of 240 horsepower was installed along with a dozen new pans of the largest scale. In 1874, the mill started crushing 40 tons a day of Silver Hill mine ore. In 1871–1872, the mill was insured for $20,000 by the Pacific Insurance Company of San Francisco. J.W. Mackay and W.S. Hobart were owners at the time.

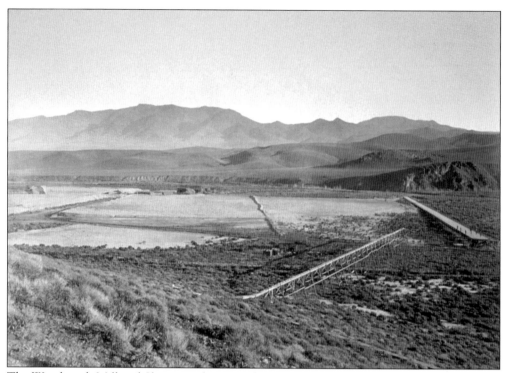

The Woodworth Mill and Sluice are shown in the photograph above. The mill is hardly visible in the background. Tailings ponds are in the middle, and the sluice is at the right. The sluice was the longest ever built up until that time and was to treat all the tailings of the 25 to 30 mills in Gold Canyon. These tailings were collected at the Bacon Mill and sluiced 3.5 miles to the Woodworth Sluice.

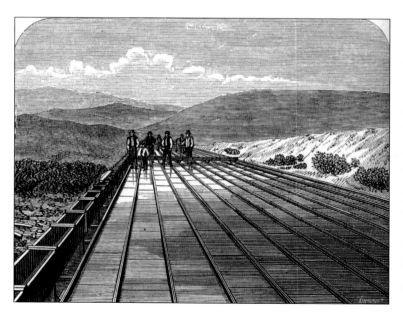

This is a close-up of the Woodworth Sluice with two sweepers and two observers working it. There were 12 individual sluices side by side, each 19 inches wide. Each sluice was separated by a 1.25-inch-wide by three-inch-high piece of wood. The total length of the sluice was 1,700 feet long.

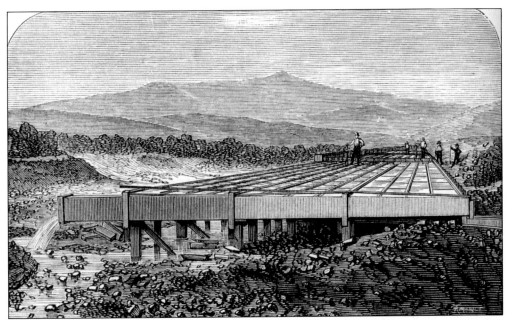

At the end of 1,200 feet, there were 10 settling tanks nine feet long, eight feet wide, and four feet deep into which the sweepings were discharged. At the end of 1,600 feet, there were two more of the same size, and at 1,700 feet, there were two more. It took 627 gallons of water per minute to wash the tailings material in the sluice.

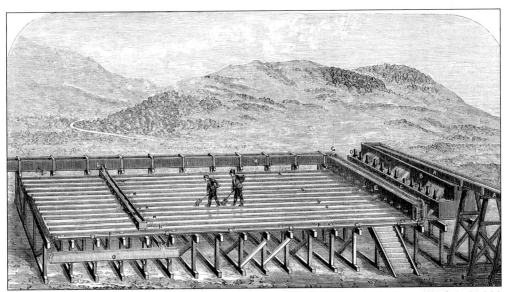

The material used to construct the sluice was enormous, including 140,000 feet of lumber, 24,000 feet of blankets (19,000 feet of which are in use at a time), two tons of nails and spikes, and 1,600 gallons of coal tar. The total cost was $21,500. It required 17 men to work the sluice, of which 12 were sweepers. They worked a 12-hour shift.

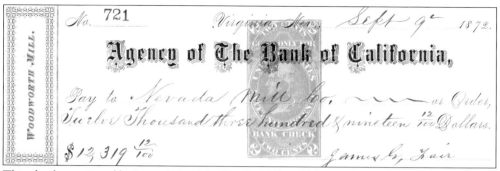

This check was signed by James Fair of the Pacific Mill and Mining Company in 1872. It appears to have been for the proceeds of working ore shipped to the mill by the Nevada Mill Company. Today there is a subdivision called the Santa Maria Ranch where the Woodworth Mill and Sluice once stood.

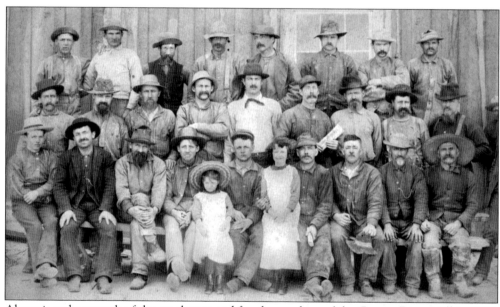

Above is a photograph of the employees and family members of the Carson River Mill in 1889. The Carson River Mill was built in 1862 and was known as Camp Woodworth. It was owned by Joseph Woodworth, William Stewart, and John Winters. It was 1.5 miles west of Dayton, running 10 stamps and four arrastras with Hungarian bowls. The machinery was driven by two turbine water wheels with the water being brought from the river in a 2,000-foot canal that was 23 feet wide. (Courtesy of the Nevada Historical Society.)

Four

MILLS IN DAYTON AND BEYOND

Many mills were close to Dayton. The Keller & Company Mill was a few hundred yards east of the Aurora/Carson River (see chapter 3). Operating in 1862 with a building 60 by 75 feet containing 15 stamps and four arrastras, which were run by a center-discharge water wheel, the venture was owned by Joseph Keller and Isaac Cohen. The Solomon & Davis Mill was a little below Keller's. Erected in 1861, it was steam powered and ran 10 arrastras. As it was an old affair from California and only capable of saving free gold, it proved a failure with the complex Comstock ore. It was removed to Como, Nevada, in 1863 and again failed and was moved to California. The Sutro Mill was next and is described below. The Dayton Mills—Old Dayton and New Dayton, also known as Dayton No. One and Dayton No. Two—were next. Dayton No. One was built in 1861, was water powered, had 15 stamps, and was owned by Ford, Berry & Company. L.J. Carr was superintendent. In 1865, the mill was updated to 20 stamps, six Wheeler pans, two eight-foot settlers, and two agitators. Dayton No. Two was built in 1864 and was steam powered with 15 stamps, eight Varney pans, four settlers, and three agitators crushing Winter's Mine ore. In 1866, both mills were owned by Winters & Kustell & Company. Winters and Robinson & Company owned the mills in 1868. The Golden Eagle Mill, which is not on the following map, was next. It was built in 1861 by O'Neale, Rule & Company with 10 stamps, 24 Knox pans, and one settler. In 1865, the water-powered Eagle Mill, owned and superintended by R.T. Mullen, had five stamps and two pans. It was upgraded in 1868 to 10 stamps, 25 pans, and 14 tubs. The Mineral Rapids Mill was built in 1861 and was owned by Colton & Smith, running 10 stamps, four 12-foot arrastras, and Hungarian pans used for gold. Johnson's method was used for silver recovery. In 1865, John Rule was proprietor with L. Dague as superintendent, and the mill was steam powered, driving 10 stamps and 14 pans and employing 13 men. Mineral Rapids was to be a town that would eclipse Dayton. Laid out in 1862, it never materialized, except for the mill that was named for it.

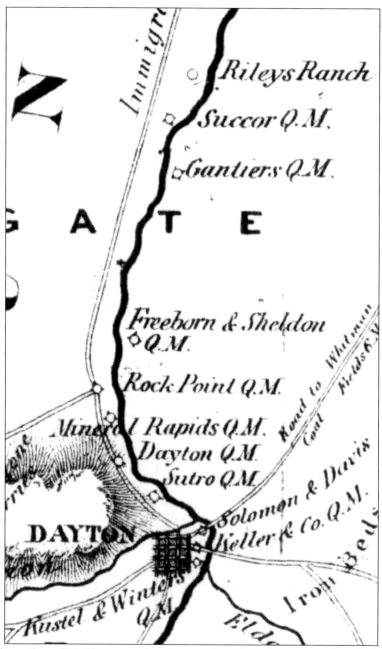

This map shows the mills in Dayton and to the east. Some have been covered in the introduction to the chapter. The Rock Point will be described below. The Freeborn & Sheldon Mill, formerly Shaw's Mill, was a quarter-mile below Dayton. Shaw's Mill never became operative, because the water Shaw and Company expected to use to run the mill was owned by the Rock Point Mill, which would not relinquish any. The Freeborn & Sheldon Mill was water powered and had a 75-foot-square main building with 24 stamps and Norton pans. It was originally owned by William Freeborn and Mark Sheldon with J.S. Aitkin as superintendent. Gantier's Mill, built in 1862 with a water ditch nearly a mile long, ran 10 stamps. The amalgamation process was Gantier's own, and he was also the superintendent. The owners were H.V. McCullough and L.P. Gantier.

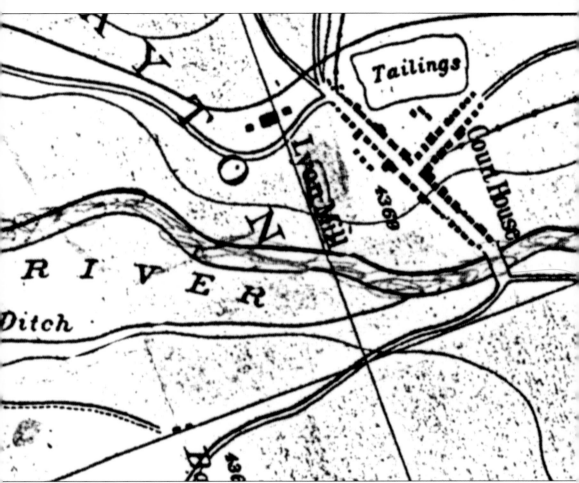

This 1877 Wheeler map charts the location of the Birdsall and Carpenter Mill, which was also known as the Lyon Mill, located on a hill on the west side of the town of Dayton. It was built around 1865 by owners Fred Birdsall and C. Carpenter. The mill contained 30 stamps, 20 Wheeler pans, 10 large Wheeler settlers, 5 agitators, 1 grinder, and 1 Blakes breaker, employing 10 men. It was water powered with a ditch from the Carson River approximately one mile long that cost $40,000 to build. The mill cost $110,000 to build. In 1886, W.T. Brown was hurt when he was adjusting the belt to start up the crushing battery at the mill and he got caught by the belt and thrown from the platform. He fell a distance of 15 feet, sustaining severe contusions on the back and chest.

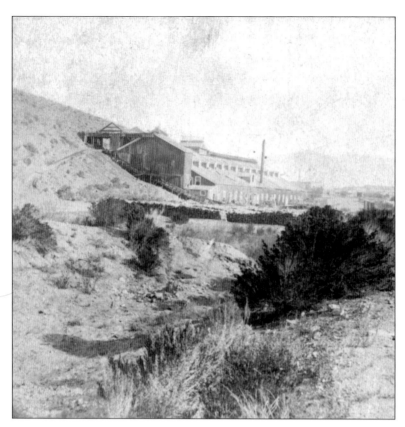

The ore that was crushed by the mill came from a mine 7.5 miles away. In 1866, the number of employees had increased to 21. The machinery was powered by a 50-foot overshoot water wheel. In 1869, Birdsall converted the mill into a tailings mill, one of the first to do so. The mill then started to process tailings from the large tailings reservoir near Gold Canyon.

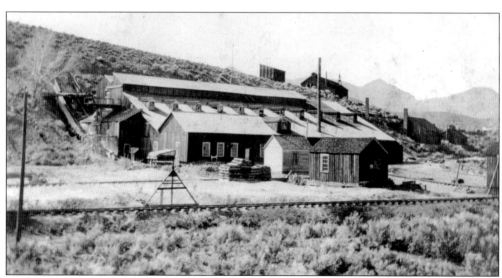

To the left of the mill is the flume and overflow, and at the top left of the mill is the water ditch. Birdsall constructed a half-mile-long railroad from the reservoir to the mill. The tracks can be seen in the foreground. A Mr. Langtry was the superintendent in 1876. He was disliked by his employees, who tried to get rid of him. (Courtesy of the Nevada Historical Society.)

The people in the photograph are unfortunately unidentified. The railroad used horses as its motive power. The mill had increased its capacity to 300 tons per day, and during the next 10 years, the output was 50,000 tons. The name of the mill was changed to the Lyon Mill and Mining Company, or Lyon Mill, with Birdsall in control. The superintendent was John Scott. (Courtesy of the Nevada Historical Society.)

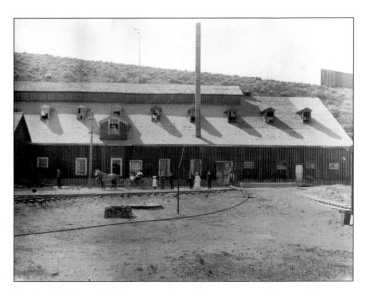

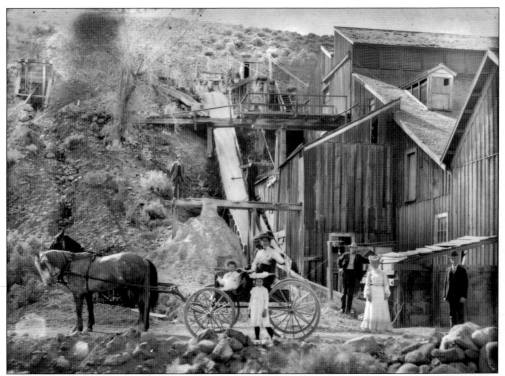

In 1880, the mill was crushing May Day Company ore from Como. In 1881, a three-foot-gauge railroad was built to bring the tailings to the mill using two steam engines. In 1882, Fred Birdsall became interested in the San Joaquin & Sierra Nevada Railroad and sold the mill to J.M. Douglass of Virginia City. This photograph was taken in 1896 when travelers visited the mill. (Courtesy of the Nevada Historical Society.)

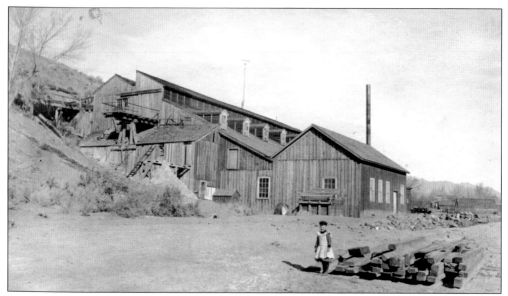

Douglass remodeled the mill and changed the name to the Douglass Mill. The mill ran tailings until around the 1890s, when it became idle. In 1896, the plant was reconstructed but failed due to an inefficient recovery system and lack of water in the Carson River. It was sold at a sheriff's sale in 1898. The mill was torn down a little after this photograph was taken. (Courtesy of the Nevada Historical Society.)

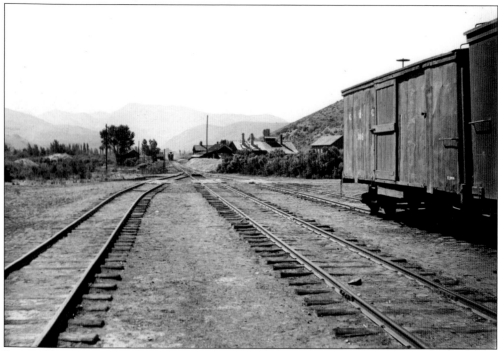

Pictured here are tracks leading to the Douglass Mill, which is in the background. The Carson & Colorado Railroad boxcars are to the right. Douglass purchased a new steam engine and named it the *Joe Douglass*. The track began at the junction with the Carson & Colorado tracks and then went almost to the town of Sutro to pick up the tailings at the reservoir.

Bill Schooley of Dayton is in the cab of the only engine used by the Dayton, Sutro & Carson Valley Railroad. The *Joe Douglass* was a 0-4-2T wood-burning steam engine built by H.K. Porter in August 1882 and delivered to the mill in September of that year. It has been restored and is displayed at the Nevada State Railroad Museum in Carson City.

Above is a photograph of what was left of the Douglass Pan Mill Dam after the flood of 1907. The remnants of the dam and ditch can be followed from the Carson River to the remains of the mill. This flood was the final blow to the once-large tailings mill that was located in Dayton. (Courtesy of the Nevada Historical Society.)

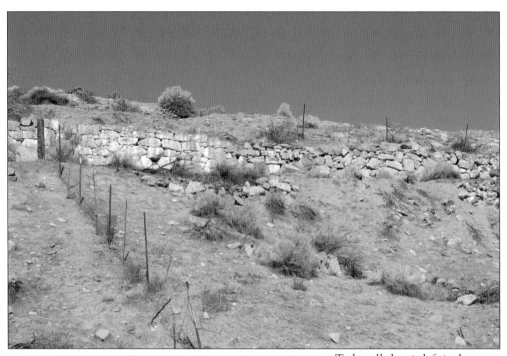

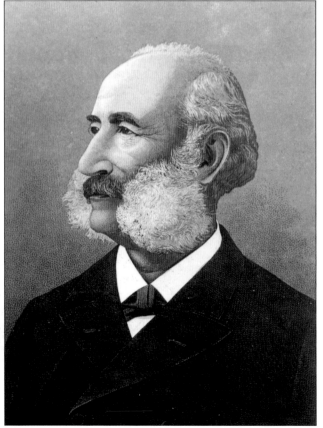

Today all that is left is the rock work on the hill where the Birdsall and Carpenter/Douglass Mill stood. The remains are on the west side of the Dayton Park on River Street. To the left of the rock work, the remnants of the water ditch can be seen. There is a plaque located at the park that has a short history of mining, dredging, and milling around Dayton.

The Sutro Mill, built in 1861 by Adolph Sutro, was a small water-powered mill with 10 stamps working Gould and Curry ore. The tailings were reworked at the mill and netted $100,000. The mill burned in 1863, killing a man sleeping there. The fire was rumored to be arson, as the mill was insured for a large sum of money. A grand jury was called to investigate, but nobody was charged. (Courtesy of Stephen E. Drew.)

The Yellow Jacket Mine, pictured here, supplied ore to the Illinois Mill, which was a quarter of a mile below Dayton and was built in 1864 for $30,000. In 1865, it was owned by Brown, French & Company, with A. Kustell as superintendent. It was steam powered with 20 stamps, six Hepburn pans, two settlers, and three agitators. William Sharon and the Bank of California owned the mill in 1866.

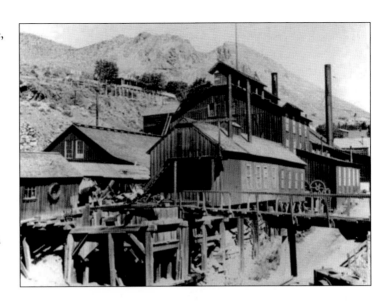

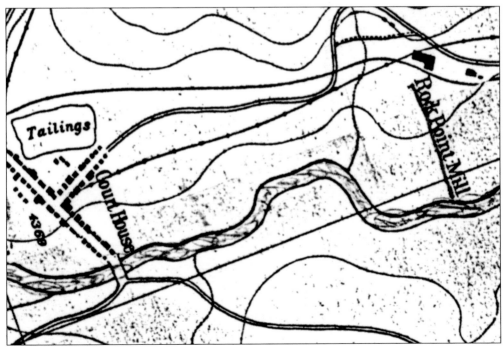

This 1877 Wheeler map shows the Rock Point Mill. The water rights for the Rocky Point Mill, as it was first called, were granted in December 1859. The locator was William R. Johnson. He deeded half of the right to a man named Francis. Johnson and Francis were partners in a store at Dayton. Johnson went to Aurora, Nevada, where he was murdered, and the four men responsible were hanged. (Courtesy of the Nevada Historical Society.)

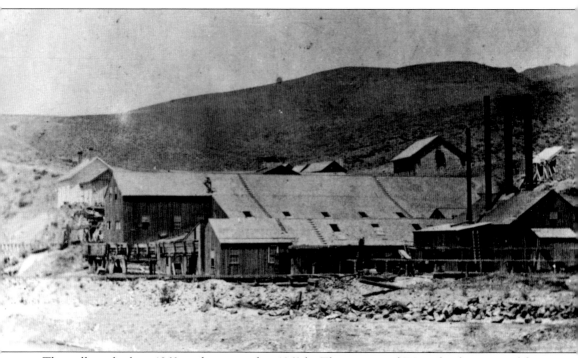

The mill was built in 1860, and it is noted in 1862 by Thompson and West's book *History of the State of Nevada 1881* that the mill was one of the most extensive establishments in the country. Owned by Hugh Logan, J.R. Logan, James P. Holmes, and John Black, the main building was 90 by 100 feet and contained 40 stamps for fine crushing, two large stamps for coarse crushing, 16 Varney pans, and 32 Howland's pans. The tailings were treated by arrastras. The water ditch was 2,000 feet in length, 900 of which was through a wooden flume 10 feet wide and three feet deep. The dam was built of stone and timber. The water ditch cost $10,000. In 1866, the mill had two overshot water wheels that ran the machinery. The owners also built a new road for hauling their rock from the mine that had a better grade and shortened the distance by over a mile. (Courtesy of the Nevada Historical Society.)

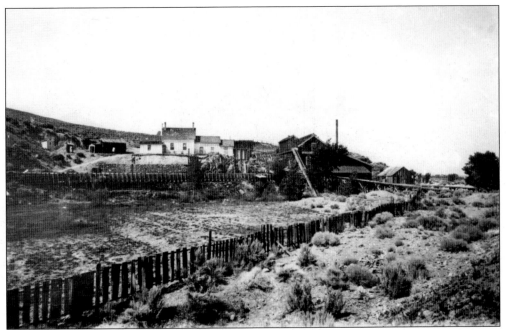

Rock Point Mill and the houses connected to the mill operation are pictured here. In 1866, the mill was owned by the Imperial Mining and Mill Company with William Bourn as president and A.F. McKay as superintendent. The mill was upgraded in 1866 to run by steam and water power with 56 stamps, 50 tubs, six Hepburn pans, and a crushing capacity of 60 tons per day.

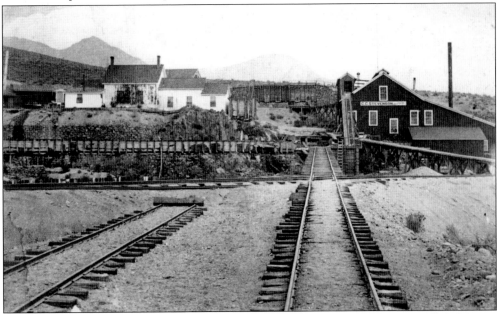

In 1868, the Rock Point Mill had an assessed value of $200,000. The Union Mill & Mining Company purchased half of the mill property in 1869. In 1871, by judge decree, William Sharon was granted the land encompassing the Rock Point Mill. In the 1880s, Evan Williams leased the mill for about three years. At this time, the mill was crushing Savage Mining Company ore. (Courtesy of the Nevada Historical Society.)

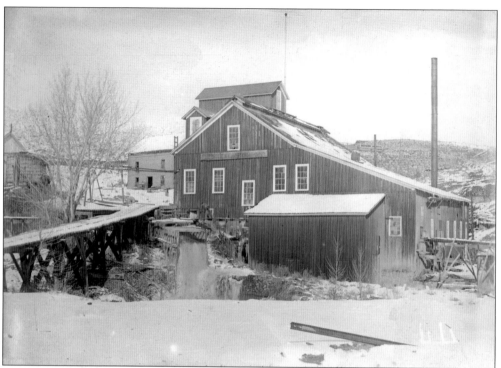

The mill burned and was completely destroyed in 1882. C.C. Stevenson leased the millsite and rebuilt the mill, moving the former Lady Bryan stamp mill machinery, which was located on the Comstock, into the building. It had 20 stamps and the usual number of pans. Then in 1899, by resolution of the Union Mill & Mining Company, the mill was sold to Herman Davis and J.C. Pierson.

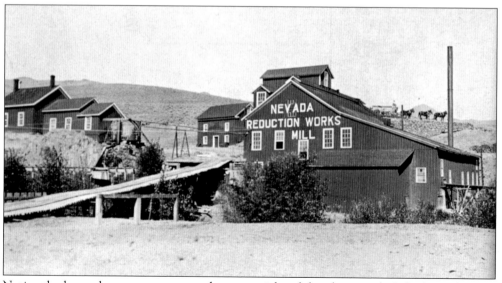

Notice the horse-drawn ore wagon to the upper right of the photograph. It had just dropped a load of ore at the top of the mill for processing. The building to the left of the mill was the Davis Assay Office, as noted on letterhead of the time. The new mill was called the Nevada Reduction Works.

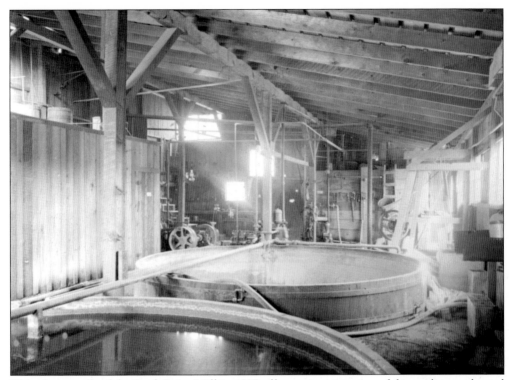

This photograph of the Rock Point Mill in 1897 offers an interior view of the settling tanks and other machinery. The mill could process 112 tons of ore per day. After the Virginia & Truckee Railroad was constructed in January 1870, the ore for the mill was freighted to Mound House, and after December 1880, it was transferred to the Carson & Colorado Railroad, which dumped the ore into bins for pickup close to the mill. (Courtesy of the Nevada Historical Society.)

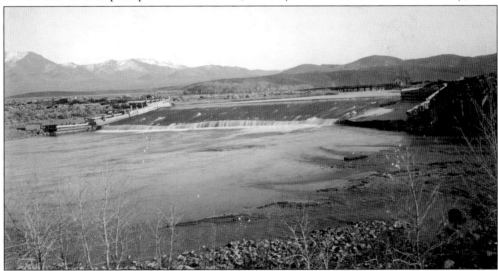

In 1898, the Rock Point Dam was a very substantial barrier across the Carson River. Particularly in the summer, the water in the river could become so low that the mills had to shut down or run at a reduced rate. It is noted in the *Territorial Enterprise* that in 1871 the Rock Point Mill could only run five of its 20 stamps. (Courtesy of the Nevada Historical Society.)

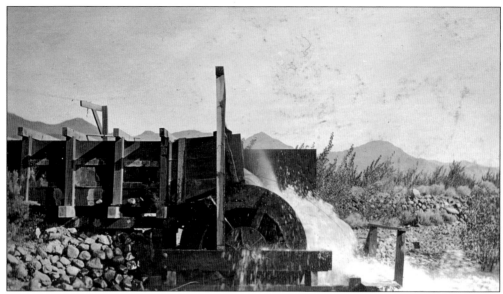

Pictured above are the two water wheels that drove the machinery of the Rock Point Mill, overshot wheels where the water goes over the top. Most of the mills had these types of water wheels. Some the mills had undershot wheels, where the water shot under the wheel. The dam and ditch for the Rock Point Mill were owned by the Union Mill & Mining Company. (Courtesy of the Nevada Historical Society.)

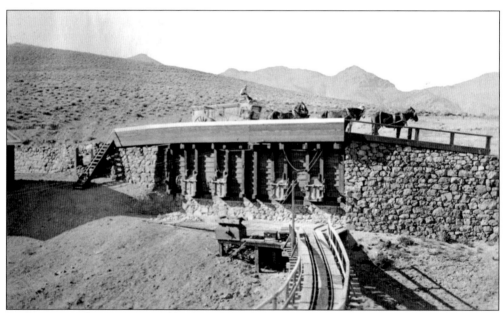

Rock Point ore bins are pictured here in the early 1900s. The ore was dumped into the bins and then taken to the mill in ore cars. These bins were behind the mill on the hill. J.C. Pierson sold his interest in the mill, and the letterhead was changed to Nevada Reductions Works, Davis and Gignoux.

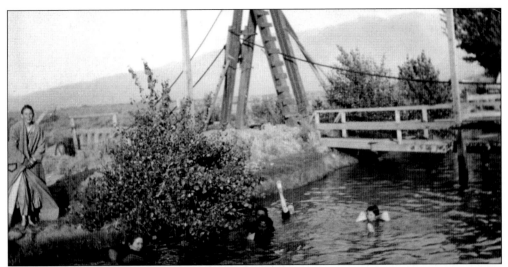

There is some thought that the mills were not good places to visit or be around. The ponds that were made along the Carson River were used for boating and fishing. Here boys are swimming in the Rock Point Ditch, which fed the water to the Rock Point Mill. Looks like it could have been a cold day. (Courtesy of the Nevada Historical Society.)

Pictured here are some tailings close to Dayton. It was estimated that over 200,000 tons of tailings are in this pond or reservoir. This is where the Douglass and Nevada Reduction Works Mills got their tailings to reprocess. The tailings ponds northwest of Dayton were dredged until one of the perimeter dams broke. The remnants of these ponds can be seen today. (Courtesy of the Nevada Historical Society.)

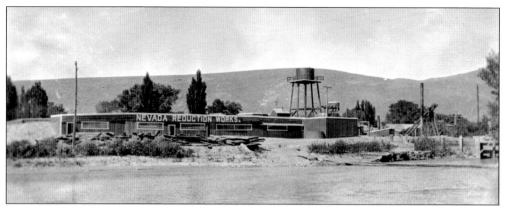

Pictured here is the Nevada Reduction Works cyanide plant. Note the pole at the left, which held telephone or telegraph lines. At one time, the Rock Point/Nevada Reduction Works Mill (the names were used interchangeably in the historical documents) was thinking of building a railroad of its own to transfer the tailings to the mill. It was going to use the rail from the abandoned Eureka Mill Railroad. This never happened. (Courtesy of the Nevada Historical Society.)

The offices of the Nevada Reduction Works are shown above. The main plant can be seen at the left. At this time, the plant and offices had electricity. The Union Mill & Mining Company was going to dismantle the Rock Point Mill as well as the Santiago Mill in 1894. The Rock Point was not dismantled. (Courtesy of the Nevada Historical Society.)

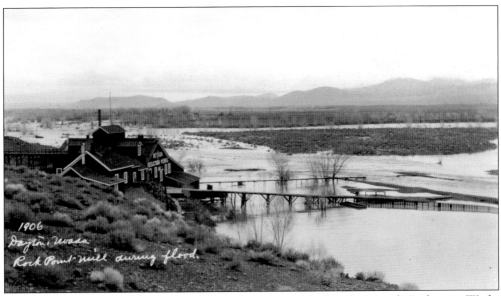

The above photograph shows just how high the water reached at the Nevada Reduction Works during the March 1907 flood. If this flood happened today, it would cover Highway 50, the main highway through Dayton. Another flood in 1911 caused the lower floor of the mill to fill with mud and debris and wrecked a number of concentrators, shutting the mill down for at least two weeks. The loss was greater than $10,000. (Courtesy of the Nevada Historical Society.)

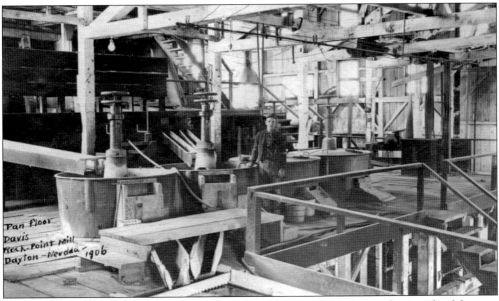

Above is a very detailed photograph of the pans. There is a wooden slot on the outside of the pan, and the discharge chute can be seen in the foreground. It looks like there are at least five pans in this photograph, but the mill had more. (Courtesy of the Nevada Historical Society.)

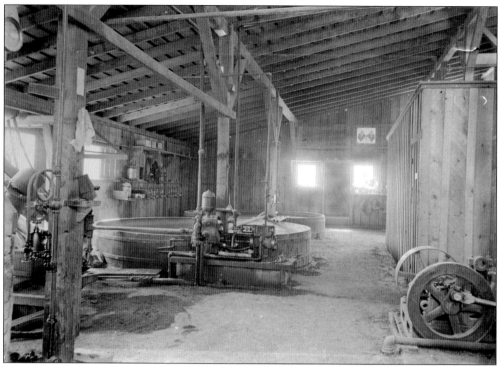

The above photograph shows the leaching room at the Nevada Reduction Works cyanide plant. Chemicals were added to the tailings along with water and placed in these large vats, which slowly mixed the solution so the cyanide could dissolve the gold and silver. The resulting mixture is called a pregnant solution. When the mill man felt all the gold and silver had been dissolved, he emptied the vats, and the solution went to the precipitating room. (Courtesy of the Nevada Historical Society.)

This is the precipitation room at the mill. Much like the Eureka Mill precipitating room, there are three boxes shown. They were locked, as can be seen on the closed box in the foreground. The dissolved gold and silver solution was run through these boxes to turn the gold and silver back into a metal form. See the Eureka Mill for a more detailed explanation. (Courtesy of the Nevada Historical Society.)

Herman Davis started this corporation and was president. The company owned both of the Nevada Reduction Works (the old Stevenson Mill/Rock Point Mill and the cyanide plant). The corporation also owned mines in Silver City, Nevada. Another name used in 1906 was the United Mining and Reduction Company. It is interesting that the Herman Davis operation had so many names.

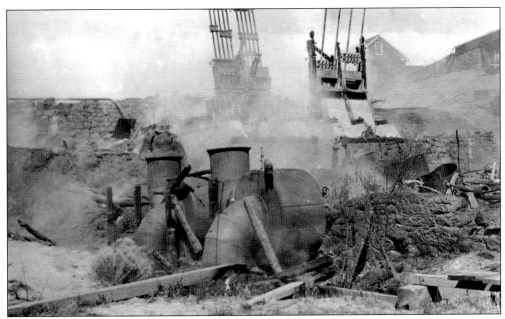

Pictured here are smoldering remains of the Rock Point Mill fire on May 3, 1909, which was started by an incendiary. The stamp batteries can be seen in the background, but the wooden structures that held them together are destroyed. All that was left was the metal, cement, and rock walls. The mill was again rebuilt but with cement and corrugated tin. A tram was being built to the company-owned Hayward Mine in Silver City. (Courtesy of the Nevada Historical Society.)

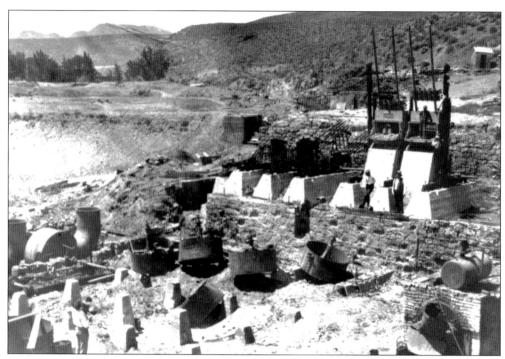

Pictured here is the debris left after the fire. Today the millsite looks much the same, except the steel has been removed. Another disaster happened at the mill when R. Lathrop received a badly lacerated scalp and other bruises and Antonio Piponia had several ribs broken and possible serious internal injuries when the men were thrown while running a car down a grade on the trestle and the car jumped the track. (Courtesy of the Nevada Historical Society.)

Capt. Herman Davis arrived in Dayton in 1893 and with his experience in dredging was hired by the Carson River Dredging Company. He started his first cyanide plant in 1897 and purchased the Rock Point Mill in 1898. In 1910, a Mr. Hotaling purchased the Nevada Mining, Reduction, and Power Company, changing the name to the Nevada Machine Reduction and Power Company. Davis moved to Reno and passed away in 1921.

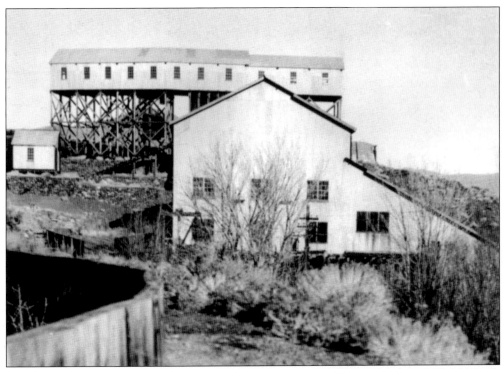

Shown here is a view of the Nevada Machine Reduction and Power Company Mill (old Rock Point) after it was rebuilt. Note the cement water tank on the hill to the right of the plant. The tailings would be placed in the upper structure and fed to the plant below for processing. The cement water tank is visible today from Highway 50 just north of Dayton. (Courtesy of the Nevada Historical Society.)

The six-foot central water wheel–powered Succor Mill, built in 1862, was owned by George Stead, Benjamin Ober, J.R.H. Waller, J.H. Moore, Henry Durant, W.S. Hobart, and Elliot J. Moore. J.B. Moore served as superintendent. The main building was 60 feet square, housing 15 stamps and Varney pans. The flood in the early 1860s changed the course of the river, and the mill was moved to Gold Hill. (Courtesy of the Nevada Historical Society.)

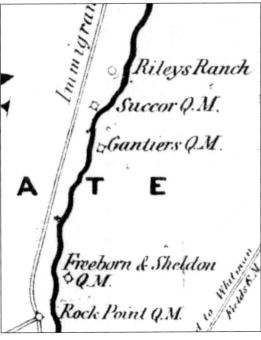

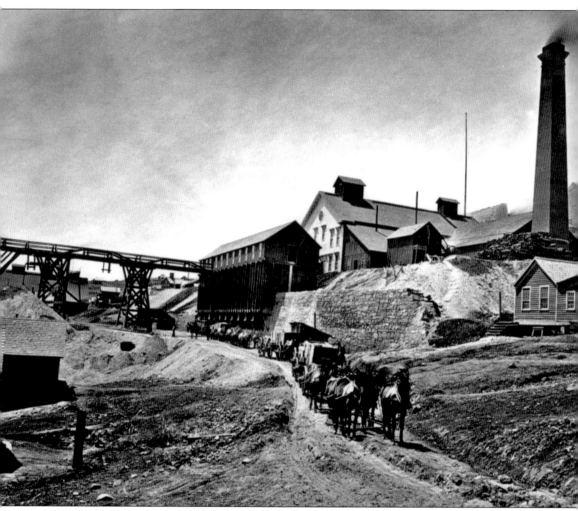

The Savage Mine, pictured above, most likely shipped ore to the other mills past Dayton and along the river. The Frothingham & Company Mill was built in 1862 with three stamps and four arrastras. Located four miles below Dayton, the operation was owned by Peter Frothingham, C.W. Rice, L.A. Rice, and John Black, and Frothingham was superintendent. The Desert Mill, owned by William Hill, was also four miles below Dayton, and in 1871, it was processing 25 to 30 tons of tailings per day. The Carson Valley Mill, as noted by the state mineralogist, was running between 1869 and 1870 five miles below Dayton near Six Mile Canyon. In 1865, Lindauer & Company/ Lindauer & Hirshman Mill was steam and water powered, running 15 stamps and 10 Wheeler pans, crushing 20 tons of Gold Hill Consolidated Mine ore per day. It was owned by Lindauer, Hirshman & Sweetapple, and H. Sweetapple was superintendent. In 1866, it was running tailings from the Rock Point Mill, but later that year, the mill was dismantled. The Hurd Mill, owned by Hurd, Ball & Company, was assessed in 1868 for $40,000, ran 20 stamps and eight pans, and was water powered.

Five

DREDGING ALONG
THE RIVER

Enormous values existed in the tailings from Comstock ore processed by the mills along the Carson River. The early processes to recover the values in the Comstock ore were crude, and as much as 40 percent of the assayed value of the ore was let out of the mill and deposited itself in the sands on the bottom of the Carson River. Later the mills built tailings ponds so the rich material could be reprocessed at a later date. The total production of the Comstock Lode has been estimated at over $400 million, but the recovered average assay value of the ore processed was not over 75 percent. Therefore, at least 25 percent of the values, estimated at $100 million, were deposited into the Carson River and tailings ponds. The mill men started noticing there were values in the discharged solutions and tried to catch some of the losses using copper plates placed in the discharge stream. Later on, as new processes were developed, which included wet-crushing (using water in the recovery process), pan amalgamation, cyanidation, and sluice boxes, the mills started to recover a higher percentage of the values in the ore. To try and recover these lost values in the Carson River and tailings ponds, dredging started around 1886 with Julio H. Rae locating placer claims along an 18-mile stretch of the river.

The first people who attempted to dredge for the lost values were Boston capitalists along with Julio H. Rae, Sol Moore, A.C. Whittier, and F.M. Huffaker, who formed the Whittier Dredge Bullion Co. It was incorporated in Nevada on February 20, 1886, with a capital stock of $1 million divided into 100,000 shares of $10 each. Other dredging companies were formed for dredging the Carson River and tailings ponds that are not included in the photographs of this chapter. Among them were the Gold Canyon Dredging Company of Dayton, Nevada, Pless Dredging and Reclamation Company of San Francisco, California, with an office at Gold Hill, Nevada, and the Oro Neva Dredging Company of Carson City, Nevada.

In January 1887, Carson River Dredging Company was incorporated in Nevada by F.M. Huffaker, Julio H. Rae, Ryman J. Turman, W.H.M. Cobb, and W.J. Douglass. The incorporation papers state the company could purchase patents, manufacture and sell machinery, dredge, mine, mill, and reduce ores. The company began to build two flat-bottom dredging scows, each 100 feet long and 25 feet to 35 feet wide with sharp bows and square sterns. The dredge would be capable of processing 1,200 tons of material a day. In December 1886, Julio Rae had a successful small steam dredge operating at Dayton. The river was to be dredged four to 90 feet deep. The material was tested, with 50 percent being quicksilver (mercury) and amalgam and 25 percent sulphurets, which were valued at $3 to $75 per ton. Sulphurets are silver mixed with sulphur, which was present in the silver ores.

This company incorporated in 1890. The Consolidated Carson River Dredging Company of Nevada was its predecessor. The assets of the consolidated enterprise were purchased by this company. The consolidated owners, Peter Forrester, Pearson Halstead, Julio H. Rae Jr., W.H.M. Cobb, Walter T. Harris, W.J. Douglass, and Robert Lewers, became trustees of the new company. Clarence G. Christie became assistant secretary, and Julio H. Rae Sr. and J. Van Vechteen Olcott were also involved. In 1892, Julio H. Rae Jr. was superintendent. In 1894, the stock was increased to two million. Herman Davis took over as superintendent.

Pictured here is a Carson River Placer Mining and Dredging dredge in 1893. The boy standing next to the dredge shows just how large the clamshell was for picking up material. An October 1892 letter to the *Engineering and Mining Journal* indicates the dredging operation had not made a successful recovery of the precious metals and quicksilver that were in the Carson River below the mills. (Courtesy of the Nevada Historical Society.)

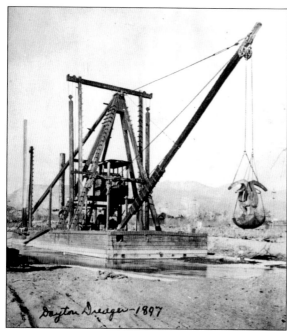

The wooden Carson River Placer Mining and Dredging Company dredge is pictured here in 1897. The large clamshell bucket is closed after taking a bite of sand and gravel from the edge of the river near Dayton, Nevada, and is ready to discharge it into the concentration plant, which separated the amalgam, mercury, gold, and silver from the rest of the material. The concentration plant amalgamator could catch considerable quicksilver (mercury) and amalgam.

Dayton Dredger–1897

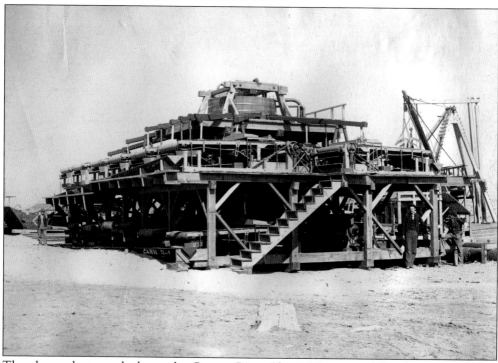

The above photograph shows the Carson River Placer Mining and Dredging Company's concentration plant in 1894. In 1897, the company constructed a 50-ton-per-day leaching plant using cyanide. This was unsuccessful, as the Comstock ore could not be treated directly by amalgamation or cyanidation. The ore needed roasting with salt to convert the silver into a chloride. Russell's process, based upon the solubility of silver chloride in a solution of sodium hyposulphite and an added solution of Edward Russell's invention, was adopted.

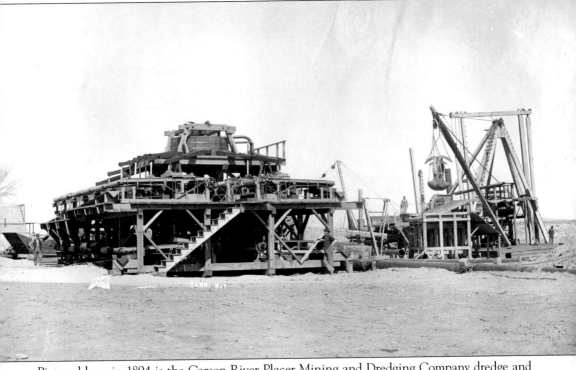

Pictured here in 1894 is the Carson River Placer Mining and Dredging Company dredge and concentration plant working the Carson River. On September 27, 1892, Dan De Quille of Virginia City remarked, "Rocks occur that cannot be lifted by suction and which break the buckets of other dredging machinery. Thus far—in all the years they have been at work—the companies have done little but make experiments with various kinds of dredging apparatus. Also they have several times altered their sluices and apparatus for securing the amalgam, free gold, sulphurets and quicksilver. At first they arranged to do all the washing, etc., on the scow, but finally carried it ashore in sluices for amalgamation, though thus far they have had very little to amalgamate. Now they are going to make a new start, beginning at the very foundation with a new boat. They now announce that they intend putting in what is called a 'clam-shell' dredger. The Bennett amalgamator is all right. It will be used in connection with the new dredge. Thus you see the outlook is not very promising."

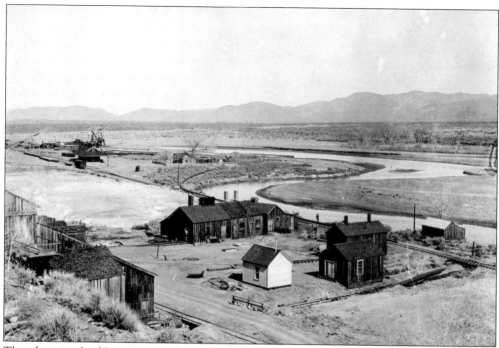

This photograph of Dayton, Nevada, in 1894 shows the Carson River Placer Mining and Dredging Company's dredge in the river at the far left. The 1894 prospectus of the Carson River Placer Mining and Dredging Company indicates sampling done in 1893 of river material showed a silver content of $4.14 to $16.95 per ton and $3 to $33.16 a ton for gold. It is not noted if this is profitable.

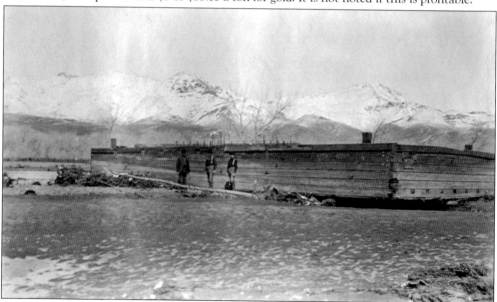

Above is a photograph taken after the 1907 flood showing all that is left of the Carson River Placer Mining and Dredging Company dredge. The height of the base is illustrated by the men standing alongside. It is not known if the machinery and other items were saved and possibly brought up from the Carson River to be used again. The flood took out railroad tracks, bridges, and homes. (Courtesy of the Nevada Historical Society.)

J.H. Rae Sr. was the president, Louise M. Raw the secretary, and J.H. Rae Jr. the resident agent. The company's office was in Dayton. Julio H. Rae Sr.'s early attempts to dredge the river using different equipment over a span of 18 years, beginning in 1886, had failed due to the type of material. Rae's noted success was in bringing electric lights and power to Dayton in 1905.

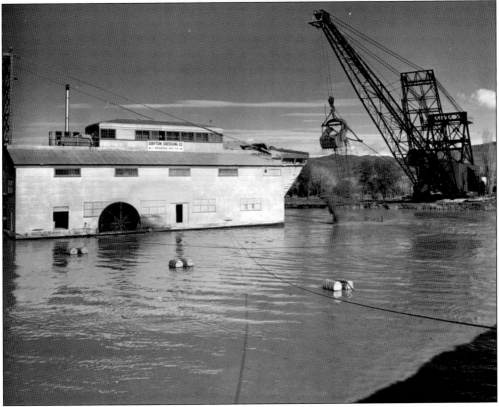

The Dayton Dredging Company, which operated its dredge from 1939 to 1942 along the Carson River riverbed at Dayton, was the largest dredge of its type in operation anywhere. The dragline and washing plant could handle as much as 15,000 cubic yards of gravel and sand per day, which contained gold and silver along with other metals that had escaped from the quartz mills along the river.

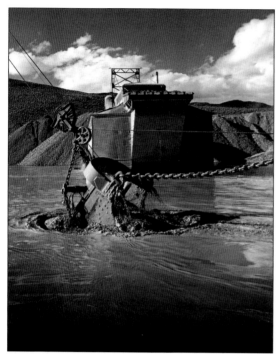

The Dayton Dredging Company's 17-ton, 24-by-20-foot bucket was capable of lifting 14 cubic yards of material in one scoop. It was attached with a cable to a 180-foot boom. The dredge could pick up material to a depth of 120 feet. The walking-type dragline was operated by two electric hoist motors, 187 horsepower each, and twin swing motors of 125 horsepower each.

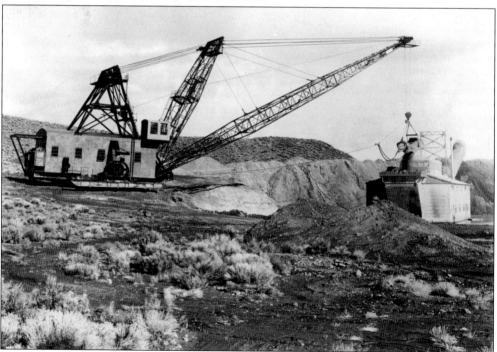

The Dayton Dredging Company dredge and concentration plant are shown in the above photograph. The concentration plant worked in a floating pond that got its water from the Carson River and Gold Hill through pipes. The dredge could walk 7.5 feet at a time. The dragline is of the Bucyrus-Monighan type, while the dredge is a product of the Bodinson Manufacturing Company of San Francisco. The processing plant used steam heat for year-round operation.

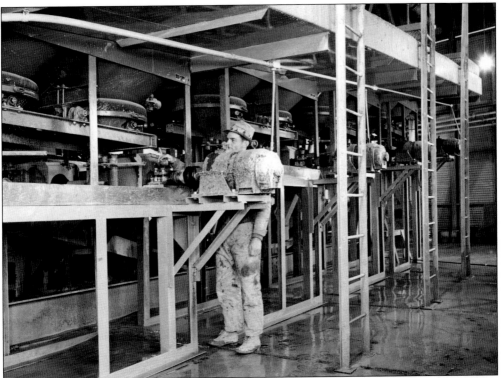

Above is a photograph taken inside the Dayton Dredging Company's concentration plant. The Westinghouse photographs on this and the following page were taken by P.S. Crocker and first used in an article in the *Reno Evening Gazette* on January 18, 1941. A good portion of the value of the dredged material was locked in the quartz, which made the recovery process more elaborate, requiring jigs, amalgamators, riffles, ball mills, and more riffles. The inscription for the above photograph reads as follows: "The dredge and concentration plant were so large it was shipped from the manufacturer in thirty four freight carloads having a total weight of 1,700,000 pounds. The concentration plant was three stories, handling a large quantity of material in a relatively small space. The concentration plant was moved in the pond by large water wheels on each side." The first inscription, PC-1101, refers to the above image, while the lower one, PC-1102, refers to the two on the next page.

PC-1101

SAND AND GRAVEL DANCE A JIG in the conical "jigs" shown in the upper background of this photo, taken aboard the huge Bodinson dredge being used by the Dayton Dredging Company in gold mining operations on the site of the historic mining town of Dayton, Nev. Westinghouse splashproof gearmotors, one of which is shown directly in front of the dredge worker, shake the jigs by means of cams on the shafts. Continually shaken, the heavier gold-bearing sands and gravel in the jigs settle to the bottom, where they are drawn off as "rougher concentrate." The rougher concentrate is passed into a "cleaner jig" and thence into an "amalgamator," in which the gold is combined with mercury prior to being heat-treated in a still-like retort ashore where the mercury is recovered and free gold obtained.

WESTINGHOUSE PHOTO

PC-1102

IN FLOATING GOLD RECOVERY PLANT---The machinery pictured here is only part of that housed in a huge 106- by 50-foot dredge being used by the Dayton Dredging Co. in gold recovery operations on the site of the historic old mining town of Dayton, Nev. The step-like device in the center is known as the "sand drag." Concentrates from the "rougher jigs" are lifted by the belt and sent into the "cleaner jig," whose concentrates go to the amalgamator and thence to the "ball mill" shown at the right. In the ball mill are hundreds of chrome steel balls about one inch in diameter. Rotated by the Westinghouse gearmotor (right center) the ball mill crushes the tiny bits of rock to almost powder consistency. Then mercury is employed to wrest the gold flecks from the crushed mass.

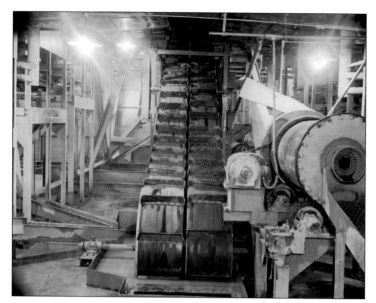

Here is another look inside the Dayton Dredging Company's dredge. Dan Avery was superintendent. The floating concentration plant was 190 feet overall. The lower deck was 106 feet long, and the upper section was 85 feet in length. In June 1942, the dredging operation was shut down by the War Production Department and parts of the dredge were shipped east to aid in the war effort.

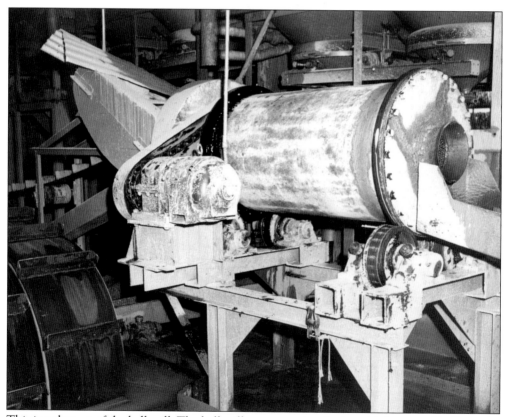

This is a close up of the ball mill. The ball mill was a rotating device with large steel balls inside. The material was introduced in the left end of this ball mill, and the balls rotating inside the mill would crush the material to the desired fineness. This was accomplished by using a screen on the outlet end. The solution would go on to further processing.

Six

CORRUPTION AT THE MILLS

Much has been written about the corruption and stock manipulation by the big owners and investors in the Comstock mines, but little is written about the corruption in the mills. The skimming of bullion by the mills had been hinted at for many years, but it was not until M.W. Fox of the Mining Stock Association and a stock holder in the Hale & Norcross Silver Mining Company filed a lawsuit that began on November 18, 1891, against the Hale & Norcross Silver Mining Company to recover $2.25 million in damages done to the stockholders that was it brought to light. The directors of the Hale & Norcross Silver Mining Company were named in the suit, as were two quartz mills: the Nevada Mill and the Mexican Mill. All the profits from the milling of the ores from the mines should have gone to the mine and been divided among the stockholders. In the two mills mentioned above, some of the valuable solution containing gold and silver was redirected to another mill area and processed without record, and the value went to the mill. The skimming process was named the "Little Joker" and housed in an annex building attached to the mill.

How did this happen? Each railroad ore car was weighed, but once the ore got to the mill and was crushed, extra sand could be added and the mill assay taken. The results of these assays would then go to the mine showing a lower gold and silver content than was truly present in the ore. Because of these practices, the real worth of the Comstock Lode will probably never be known. The lawsuit was not resolved for at least seven years, as it was appealed to the California Supreme Court multiple times. Alvinza Hayward, W.S. Hobart, the Nevada Mill and Mining Company, and H.M. Levy were found to be members of the conspiracy during all of the times covered by the complaint, and they were all liable in the full amount of $1,011,835. In the final judgment, after the many appeals, Alvinza Hayward and the estate of W.S. Hobart were liable for $294,000.

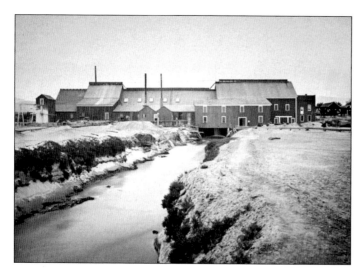

In 1871, Alvinza Hayward purchased the Mexican Mill property, half interest in the mill, and half interest in the Mexican Ditch and Dam. Assessment records show that the mill was owned by the Nevada Mill Company, which was owned by Alvinza Hayward and John P. Jones. The Hale & Norcross Company was processing approximately 1,000 tons of ore per month at the Mexican Mill.

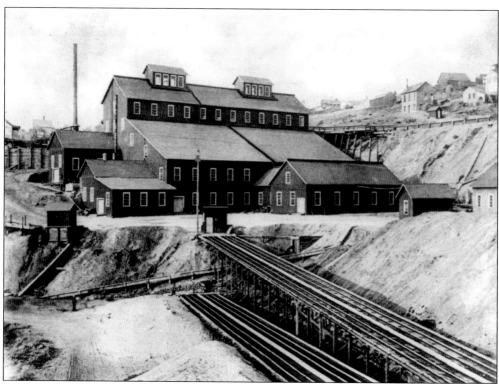

The Nevada Mill was located in Virginia City; the annex where the stolen bullion was processed is attached to the mill in the left foreground; the left wall has three windows and a door. The tank from which the unprocessed solution containing gold and silver values was scooped can be seen between the annex and the building behind it, which has two windows and a door on the left side.

Above is the Nevada Mill annex in 1891, showing the sand tank located just to the left of the annex building, extending from inside the mill through a door opening out to the front of the annex. This tank contains the solution that came through the screen in front of the stamp battery before it was put through the amalgamating pans, containing the full value of the ore crushed.

An employee of the mill dips the bullion solution out of the tank and dumps it into a hole leading to the annex containing the "Little Joker," where the values were illegally recovered. This employee was working for the directors named in the lawsuit. On one lot of ore, the mill returned less than 22 percent of the value of the ore.

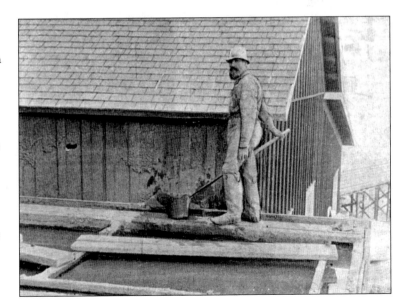

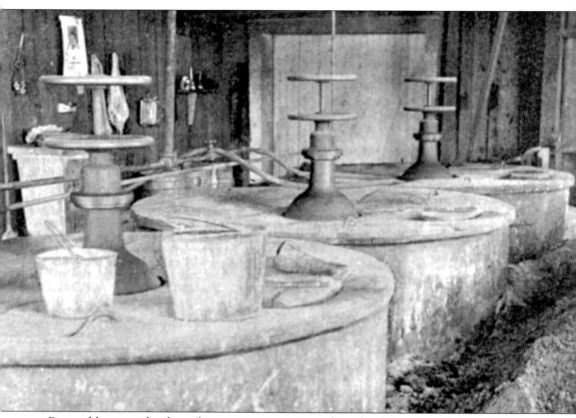

Pictured here are the three slow-motion pans, situated inside of the annex, where the bullion solution was processed. The resultant bullion recovery from these pans went to the directors and owners of the Hale & Norcross Mine, of which some were also the owners of the mill, and not to the stockholders, the supposed recipients. By milling ore in this manner, from 88,887 tons or more, the gross value of which was $3,505,361.37, the mill returns to the Hale & Norcross Silver Mining Company only amounted to $1,826,873.80. From these 88,887 tons milled, the Hale & Norcross Silver Mining Company got back a little over 50 percent of the value of the ore it furnished for reduction. Add to this that the Hale & Norcross Silver Mining Company was also charged $7 a ton for the milling the ore by the mills.

Alvinza Hayward (1822–1904) was born in Vermont, and he studied law in New York before coming to California in 1850. He was involved in the Eureka Mine in Amador County and after 1864 held substantial interests in the Comstock mines and the Nevada Mill, Mexican Mill, Morgan Mill, Brunswick Mill, and others. One of the directors of the Bank of California, he was reportedly California's first millionaire.

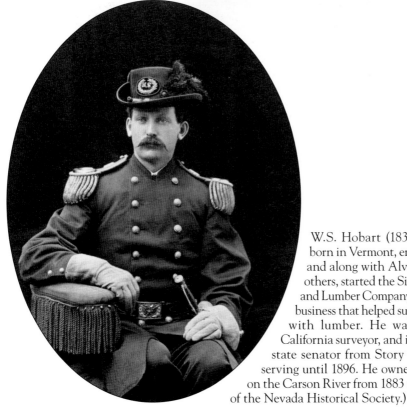

W.S. Hobart (1839–1892) was also born in Vermont, ended up in Nevada, and along with Alvinza Hayward and others, started the Sierra Nevada Wood and Lumber Company, a large lumbering business that helped supply the Comstock with lumber. He was a Nevada and California surveyor, and in 1872, he became state senator from Story County, Nevada, serving until 1896. He owned the Eureka Mill on the Carson River from 1883 to 1884. (Courtesy of the Nevada Historical Society.)

Evan Williams was born in Blossburgh City, Pennsylvania, in 1844. He came to Nevada around 1868. He became superintendent of the Nevada Mill and the Mexican Mill in 1881 and was a stockholder and vice president of the Bullion and Exchange Bank at Carson. His brother-in-law was Gold Hill assayer W.S. James. The court records indicate that when Williams started as superintendent of the Mexican Mill in 1881, he had a salary of $300 per month. He was worth at least $1 million in 1891. It was also brought out that Williams made midnight rides along the lonely toll road from Empire to the assay office of his brother-in-law James in a heavily loaded cart with suspicious looking bags, indicating he might be carrying gold and silver values to be smelted. Another suspicious note is that Evan Williams, along with the other individuals that were questioned from the Bullion and Exchange Bank, refused to show the court the bank's books. (Courtesy of the Nevada Historical Society.)

Theodore Robert Hofer came to Nevada from Maryland in 1869. He worked for the US Mint and the Bullion and Exchange Bank in Carson City simultaneously during the corruption period. Large amounts of bullion were deposited at the US Mint in the names of Hofer, a Mr. Peters, and H.K. Brown. They refused to answer questions as to the bullion's identity. According to court records, all of this bullion remains unaccounted for. (Courtesy of the Nevada Historical Society.)

To those who want to pan the Carson River to obtain some of the values left behind by the mills, beware. Over time, mercury changes form and becomes methyl-mercury, which is highly poisonous. The mercury in the river should be starting to turn to that state. It is easily absorbed into the body and can have disastrous results. The Carson River is now a government superfund site to determine the severity of contamination.

DISCOVER THOUSANDS OF LOCAL HISTORY BOOKS FEATURING MILLIONS OF VINTAGE IMAGES

Arcadia Publishing, the leading local history publisher in the United States, is committed to making history accessible and meaningful through publishing books that celebrate and preserve the heritage of America's people and places.

Find more books like this at
www.arcadiapublishing.com

Search for your hometown history, your old stomping grounds, and even your favorite sports team.

Consistent with our mission to preserve history on a local level, this book was printed in South Carolina on American-made paper and manufactured entirely in the United States. Products carrying the accredited Forest Stewardship Council (FSC) label are printed on 100 percent FSC-certified paper.

MADE IN THE USA